A CLOSER LOOK
COLOUR

David Bomford and Ashok Roy

NATIONAL GALLERY COMPANY, LONDON
DISTRIBUTED BY YALE UNIVERSITY PRESS

David Bomford is Associate Director for Collections at the J. Paul
Getty Museum, Los Angeles. Ashok Roy is Director of Scientific
Research at the National Gallery, London. Both authors have
contributed to many National Gallery publications, including
The National Gallery Technical Bulletin and the exhibition series
Art in the Making (1989–2006).

Take *A Closer Look* with these guides,
produced by the National Gallery, London:
Conservation of Paintings

Coming soon:
Faces
Frames
Saints

Front cover, page 1 and title page: Titian, *Bacchus and Ariadne*, 1520–3
(details)

First published in Great Britain as *Pocket Guides: Colour* in 2000
Revised edition published 2009
by National Gallery Company Limited
St Vincent House, 30 Orange Street, London WC2H 7HH
ISBN 978 1 85709 442 8
525552
British Library Cataloguing-in-Publication Data.
A catalogue record is available from the British Library.
Library of Congress Catalog Card Number: 99 70237

Written by David Bomford and Ashok Roy
Edited by Felicity Luard and Nicola Coldstream

Project Editor for the 2009 edition: Claire Young
Designed by Heather Bowen
Cover designed by Smith & Gilmour
Printed and bound in Hong Kong by Printing Express

CONTENTS

INTRODUCTION

The art of the past was astonishingly colourful: not only paintings, but wall paintings, tapestries, painted architectural ornament, polychromed sculpture, enamels and every kind of brilliant artefact were used to decorate sumptuous medieval and Renaissance churches and palaces. This exuberant celebration of the richness of colour has now largely disappeared from religious and secular buildings, and is impossible to recapture; however, through paintings we can attempt to trace the development of colour through the centuries. Many pictures have themselves perished or changed, certainly, but enough have been preserved for us to chart the emergence and use of different materials, the ebb and flow of theory and practice, and the ever-changing range of artistic ambition and achievement. The selection of paintings described in this book was chosen to represent the chronological span of the National Gallery Collection, and take us on a compelling journey from the late medieval colour systems described by Cennino Cennini (p. 55) to the methods of Georges Seurat. On the way, we encounter painters who used colour with extraordinary skill to represent the world about them or to codify significance beyond the visible [1].

Painting the Coloured World

Colour – along with light, shadow and movement – defines everything that we see. We have only to consider the limitations of old black and white television images to realise how much sensory information colour conveys. The mechanics of colour vision are complex but, essentially, the retina of the human eye (if it functions correctly) receives light of different wavelengths and intensities which the brain interprets as particular colours of varying brightness. Moreover, since we normally have binocular vision, we can see the three-dimensional world around us in depth. The human brain unconsciously processes all these visual sensations into a living picture of the multilayered world that we inhabit.

A painter attempting to depict the coloured world encounters certain basic difficulties. Human vision routinely distinguishes nuances of depth, structure and surface, but the painter has to reinterpret these commonplace observations in two dimensions – more or less flat patches of colour suggesting three-dimensional form and material substance. The relation between outline and colour in representational painting exercised painters from the sixteenth century on. Which was the essential defining element of a form – its drawn shape or its colour? The debate among painters and theoreticians reached its peak and some sort of a conclusion in the eighteenth century.

Modern taste has tended to admire a freedom of coloured brushstrokes not necessarily confined by strict boundaries – but most painters, from ancient times to the present, have combined drawing and colour in their search for a likeness of the external world. They have developed conventions of representation in which descriptive colour is modified with darker and lighter tones to indicate form and texture. Jean de Dinteville's red satin sleeve in Holbein's 'The Ambassadors' [2], for example, appears remarkably lifelike not only because it is precisely outlined and convincingly crimson, but also because shadows, half-shadows, highlights and an overall silvery sheen combine to depict a piece of gleaming, sumptuous fabric that is utterly tangible. Holbein's mastery – and the endeavour of all representational painting – has been to interpret and transform observations of light and shade, tone and texture into a pattern of colours on a flat surface that reconstitutes an illusion of what was seen.

Throughout history, the painter's palette – the range of colours – has been dictated by several factors: the availability of materials,

artistic or religious convention, stylistic influences and so on. Colour, as much as subject matter, style and composition, enables us to recognise paintings as typical of a particular period, place or artist. Only in the twentieth century has the movement towards abstraction, and an unprecedented freedom in choice of materials and subject matter, enabled painters to divorce colour from the traditional demands of representational art.

For centuries, the artist's palette in European painting was limited, although with certain regional variations. For example, Venice, as a centre of trade for dyes, textiles and the glass-making industry, offered access to unusual imported pigments and Venetian painting was always notable for the richness and brilliance of its colour (see p. 77).

Artists also generally tailored their palettes to the requirements of their art. Thus, a painter working under the grey skies of northern Europe might use a more subdued palette than a painter working in Italy. This point is tellingly made by comparing an Italian and a French landscape, both by Corot [3, 4]. If an artist was working under specific instructions from a patron or commission, extra payments might be made in order to ensure that only the finest materials were used. In some cases – Duccio's *Maestà*, for example – the patron actually supplied the materials [5].

It was sometimes possible for artists to match exactly, in paint, what they saw about them, even to the extent of using the same materials – a painter of landscape could use earth colours which were the literal equivalents of the reds, browns and yellows observed in nature. For the most part, though, conventions of representation grew up based on mixtures of available colours – red and white for the flesh tones of European faces, artificial greens or blue and yellow mixtures for foliage, and blues mixed with white for the optical blue of the sky.

The imitation of different materials set particular challenges for the painter, and colour provided vital clues about surface texture – the reflective gleam of metal or ceramic [6], the soft drape or crisp folds of a fabric, the dull glow of wood [7], the warm, porous surface of brick and the cool hardness of marble. A matte quality or lustre were conveyed by the careful inclusion or omission of sharp or diffused surface reflections.

One intriguing example was the depiction of gold objects. The actual material, in the form of gold leaf, was available – and was extensively used up to the fifteenth century to make altarpieces and panels resemble opulent artefacts made out of the solid metal. However, for representing golden items in a realistic setting, and rendering illusionistic reflections, gold itself

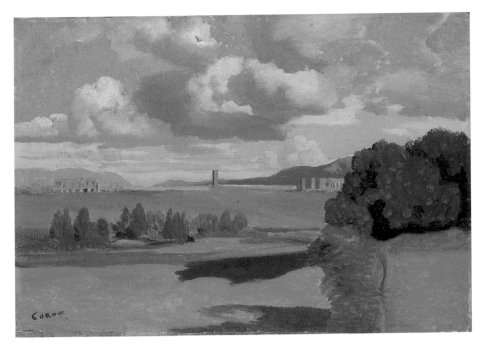

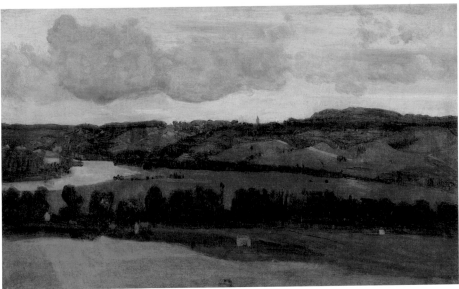

3. Jean-Baptiste-Camille Corot,
*The Roman Campagna, with the
Claudian Aqueduct*, probably 1826.

4. Jean-Baptiste-Camille Corot, *The
Seine near Rouen*, probably 1830–5.

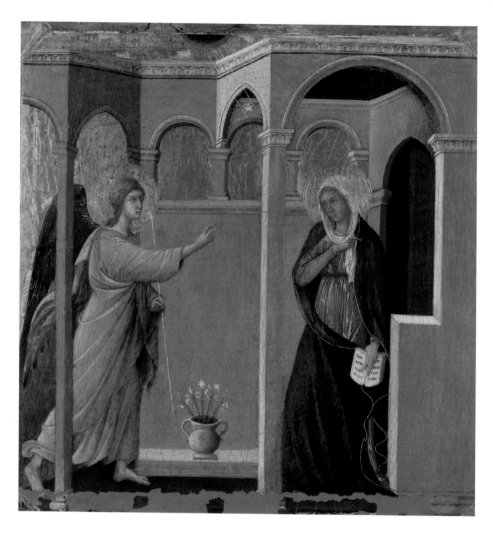

5. Duccio, *The Annunciation*, 1311. This is a panel from the predella of the *Maestà* altarpiece, painted for the high altar of Siena Cathedral, Italy.

could be strikingly unsuccessful. Gold leaf shining on a picture surface reflects the real light present in the viewer's space – not the imaginary light within the painting – and objects represented by it often appear flat and unconvincing. Artists were well aware that the illusion is much more complete if yellow paint – with carefully positioned lights, shadows and reflections – is used instead. Leon Battista Alberti wrote of this problem in his *Della Pittura* (*On Painting*) of 1435–6: 'Even though one should paint Virgil's Dido whose quiver was of gold, her golden hair knotted with gold, and her purple robe girdled with pure gold, the reins of the horse and everything of gold, I should not wish gold to be used, for there is more admiration and praise for the painter who

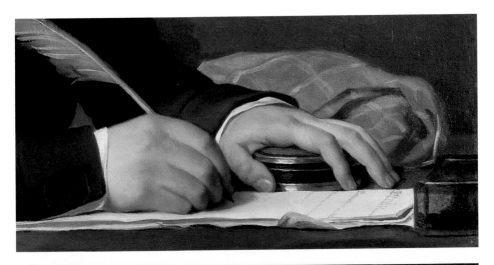

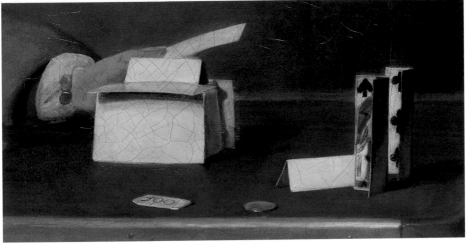

6. Jacques-Louis David, *Portrait of Jacobus Blauw*, 1795 (detail).

7. Jean-Siméon Chardin, *The House of Cards*, about 1736–7 (detail).

imitates the rays of gold with colours...in a flat panel with a gold ground...some planes shine where they ought to be dark and are dark where they ought to be light.'

A striking example of this phenomenon is in *Saints Peter and Dorothy* by the Master of the Saint Bartholomew Altarpiece [8], in which Saint Peter holds a pair of shining keys, one gold and one silver, which are painted and appear convincingly solid and metallic; behind them is a cloth of gold, which is made of real gold leaf but appears featureless and unlike a textile, with its flat, even reflections. The contrast between paint successfully imitating metal and gold leaf standing unconvincingly for a golden fabric is particularly telling here.

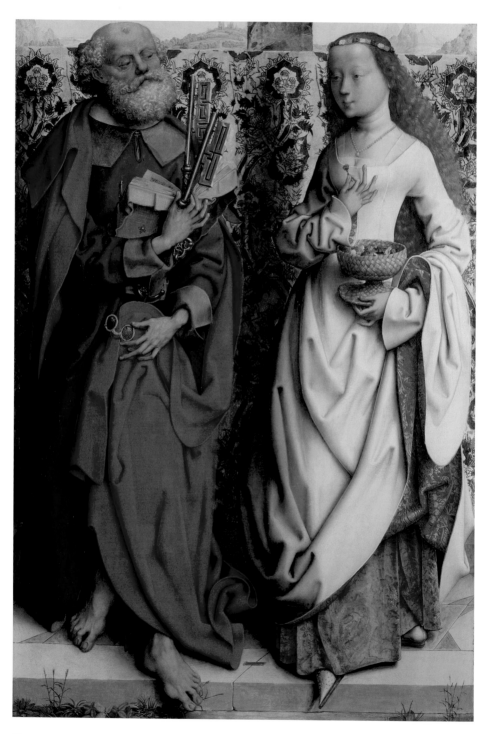

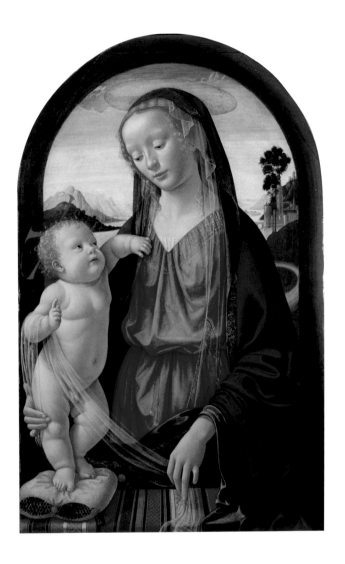

The Perception of Colour

8. Master of the Saint Bartholomew Altarpiece, *Saints Peter and Dorothy*, probably 1505–10 (detail).

9. Domenico Ghirlandaio, *The Virgin and Child*, probably about 1480–90.

Colour in painting is used most straightforwardly to record the literal colours of the visible world; but it may not simply be descriptive. It may, for example, be used to suggest depth and distance. It is a common observation that the atmosphere lends a slightly misty, bluish cast to more distant objects and this effect was imitated by painters from the fifteenth century on by setting down landscapes in a series of receding bands of colour – warmer and darker in the near distance and successively bluer, cooler and

13

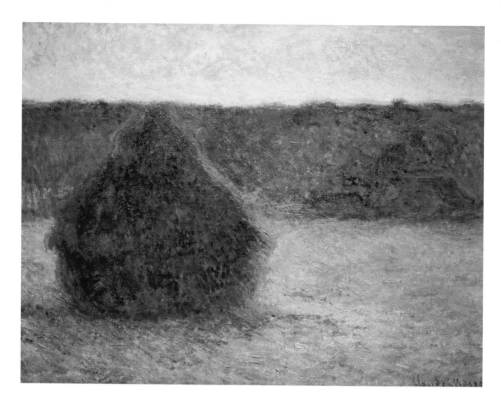

10. Claude-Oscar Monet, *Haystacks at Sunset, Frosty Weather*, 1891. Private collection.

paler in the middle and far distance, a phenomenon noted in Leonardo da Vinci's influential manuscript, *Trattato della Pittura*. This is a convention known as aerial perspective and many paintings have landscape backgrounds constructed in this way. One of the clearest examples is the vista of hills and mountains that stretches away behind Ghirlandaio's *Virgin and Child* [9].

Painters may also try to represent colour that the eye and brain think they are seeing even though it is not actually present. In 1856, Delacroix described in his journal a boy climbing on a fountain by Saint-Sulpice: 'I saw him in full sunlight – orange in the lights, very lively violet tones for the parts emerging from shadow, and golden reflections in the shadows turned towards the ground.' Delacroix is actually recording two quite separate phenomena here. His first observation – of shadows apparently tinged with violet – is a physiological reaction of the human eye dazzled by yellow-orange sunlight. Goethe, in his influential *Theory of Colours* (*Zur Farbenlehre*, 1810), described the process more fully: 'During the day, owing to the yellowish hue of the snow, shadows tending to violet had been observable; these might now be pronounced decidedly blue as the illumined parts

11. Anthony Van Dyck, *Lady Elizabeth Thimbelby and Dorothy, Viscountess Andover*, about 1637 (detail).

exhibited a yellow deepening to orange. But as the sun at last was about to set and its rays, greatly mitigated by the thicker vapours, began to diffuse a most beautiful red colour over the whole scene around me, the shadow colour changed to a green, in lightness to be compared to a sea-green, in beauty the green of an emerald.' This phenomenon of induced colour was subsequently pursued by the Impressionists, whose frequent use of half-shadows tinted with the complementary (opposite) colour of the highlights was at first derided and later imitated (see pp. 61–5) [10].

Delacroix's second observation – of bright light reflected off nearby objects into the deepest shadow – is real, not induced. Shadows are full of stray reflections from surrounding light sources, and painters since the Renaissance have included them to reinforce the sense of roundness and form of objects on their unlit sides. In Van Dyck's *Lady Elizabeth Thimbelby and Dorothy, Viscountess Andover* [11], for example, we find that the artist has used coloured reflections extensively to convey depth and reality: Cupid's shadowed face is scarlet from his own crimson robe, and both the underside of his right forearm and the catchlight in his eye are bright yellow from the Viscountess's gold dress.

15

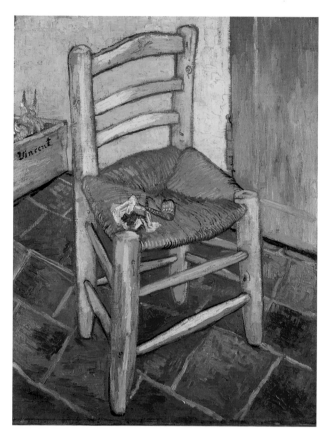

Symbolism and Emotion

Colour may also be a direct expression of emotion – not physical, not physiological, but a visible manifestation of the artist's mood, or of the feelings that he or she wishes to evoke. Colour influences our response to paintings, just as it does in everyday life. Perhaps the clearest example of a painter's inner turmoil translating itself into colour and shape is the work of Vincent van Gogh. Of his famous painting *The Night Café* (Yale University Art Gallery) he wrote: 'I have tried to express the terrible passions of humanity by means of red and green. The room is blood red and dark yellow with a green billiard table in the middle; there are four citron-yellow lamps with a glow of orange and green. Everywhere there is a clash of the most disparate reds and greens...'. This deliberate juxtaposition of contrasting colours (see p. 61) is seen in a more muted way in *Van Gogh's Chair* [12]. The yellow chair is outlined with blue-green, which both reflects the wall colour and contrasts

13. Duccio, *Triptych: The Virgin and Child with Saints Dominic and Aurea*, about 1315 (detail).

with the dull orange-red of the floor tiles, setting up subtle vibrations of tone on the retina of the observer. Van Gogh freely admitted the artificiality of his art and the impossibility of matching his materials to his perceptions: '...a painter had better start from the colours on his palette than from the colours in nature.'

We quickly recognise the use of colour to convey emotional impact, especially in modern paintings; however, colour used for purely symbolic as opposed to descriptive or emotive ends is as old as painting itself. In particular, there were certain widely accepted conventions in the painting of religious subjects. In Italian painting, the Virgin's cloak was usually blue, the colour of heaven, and was frequently painted with natural ultramarine, made from lapis lazuli, the most prized and expensive of pigments [13]; Mary Magdalene was often in red [14], Saint Peter in yellow and blue [15], and so on. A symbolism of pattern and harmony also developed in more complex works. In large, elaborate compositions such as densely populated altarpieces, painters

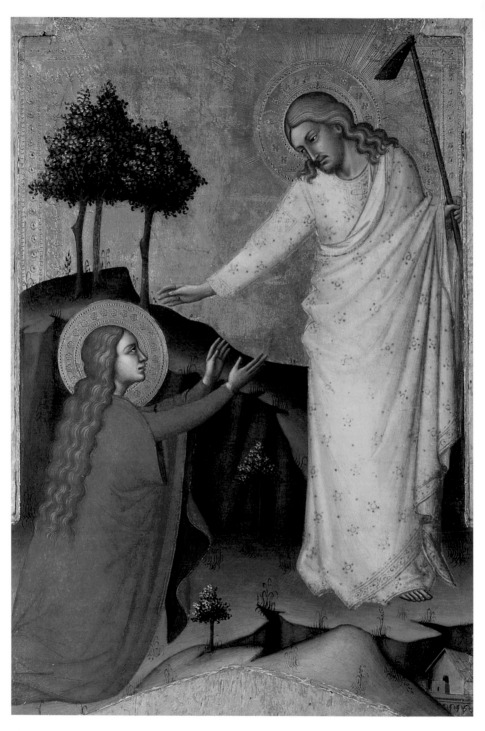

might organise their colours in elaborate repetitions. In Lorenzo Monaco's great altarpiece of *The Coronation of the Virgin*, for example, the brilliantly dressed figures of saints and angels are arranged in a chromatic symmetry in which the colours of the left half are reflected on the right – sometimes directly, as in the semicircle of angels and in the two saints dressed in white, and sometimes less directly as in the yellow and blue of Saint Peter, on the right, echoed in the blue and yellow of Saint Paul on the left [15]. At the centre of Monaco's altarpiece the Virgin herself is apparently dressed in mauve and blue. Studying the materials of which these colours are made has revealed a significant change: the mauve robe was originally a delicate plum colour – but a red lake pigment has faded. Under the microscope, small passages protected from the light by decorative gold leaf at the surface are seen still to have their original colour – a reminder of the physical nature of paint and its frailties.

In the pages that follow, we shall look at the materials of colour, and how painters have used different combinations of coloured pigments and binding media, in mixtures, or layer upon layer, to achieve specific colour effects.

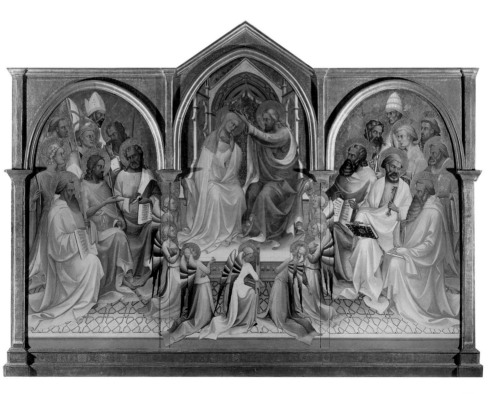

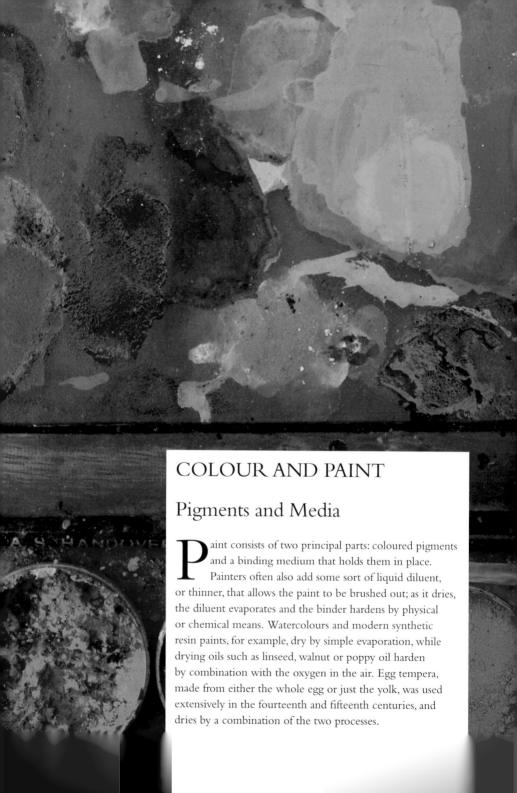

COLOUR AND PAINT

Pigments and Media

Paint consists of two principal parts: coloured pigments and a binding medium that holds them in place. Painters often also add some sort of liquid diluent, or thinner, that allows the paint to be brushed out; as it dries, the diluent evaporates and the binder hardens by physical or chemical means. Watercolours and modern synthetic resin paints, for example, dry by simple evaporation, while drying oils such as linseed, walnut or poppy oil harden by combination with the oxygen in the air. Egg tempera, made from either the whole egg or just the yolk, was used extensively in the fourteenth and fifteenth centuries, and dries by a combination of the two processes.

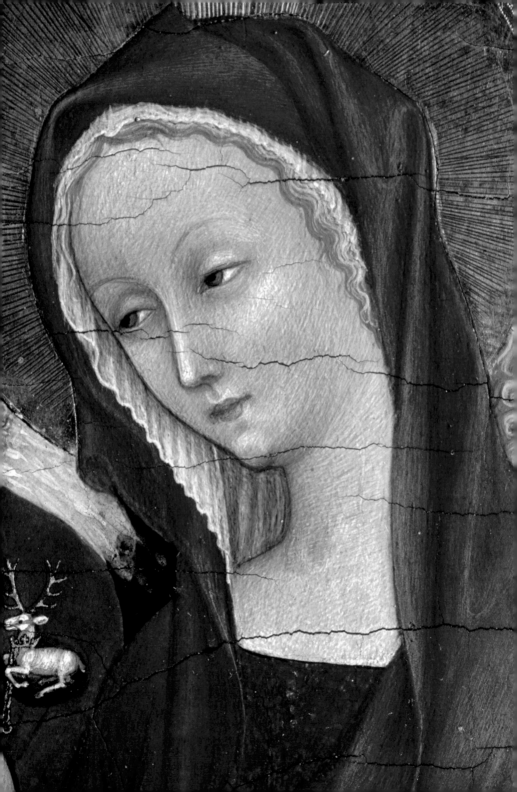

16. English or French (?), *The Wilton Diptych*, about 1395–9. Detail showing hatching on the Virgin's face built up in layers of egg tempera paint.

17. Rembrandt, *Belshazzar's Feast*, about 1636–8. Detail of 76, with the elaborate collar rendered with thick oil paint (impasto).

18. Dirk Bouts, *The Entombment*, probably 1450s. Detail of 68, showing the fragile surface of a glue tempera painting.

The way in which a paint dries affects the way a painter uses it: egg tempera dries quite quickly and forms are best built up with a succession of short hatched strokes laid alongside or across each other [16]. Oils, by contrast, are slow drying, allowing the artist time to blend them into soft, continuous transitions. The medium can be fluid or viscous when wet, flat or textured when dry – and painters have often turned the plasticity of the paint itself to their advantage, modelling it until its own surface imitated the surface of the things depicted [17].

The appearance of a paint layer depends on the characteristics of both pigment and medium: the same pigment used in different media can appear matt or glossy, opaque or transparent, dull or brilliant. In general, oil paint appears richer, darker and glossier (more 'saturated' is the technical term) than water-based media such as egg tempera [16], glue [18] or fresco [19], which tend to look lighter, brighter and chalkier.

19. Spinello Aretino, *Two Haloed Mourners*, about 1387–95. A fragment of a fresco showing the characteristic light tonality of this technique.

A pigment's colour is determined by the way it absorbs certain parts of the spectrum that make up visible light and reflects others. Thus a brilliant opaque red such as vermilion reflects a great deal of red light, but absorbs the blue, green and yellow parts of white light. Some pigments are valued for their opacity and covering power; others (such as lakes, see p. 41) for their translucency and consequently their suitability for glazes: the final, transparent oil layers applied over a more opaque paint layer to intensify and enrich the colour.

In addition, the colour of the 'ground' – the layer first applied to a wood or canvas support before painting – has a significant effect on the overall tonality of the painting, as well as on painting technique. Italian and northern European painters of the fourteenth and fifteenth centuries used white grounds which heightened the brilliance and luminosity of the paint layer.

20. Detail of 13, showing green underpaint which has become more visible over time.

From the sixteenth century, and particularly in the seventeenth and eighteenth centuries, painters such as Poussin, Velázquez, Rembrandt and Tiepolo (see pp. 81–8) excelled in exploiting coloured grounds, and a more varied oil painting technique, to produce a wide range of optical effects. The paint medium becomes increasingly transparent over time, so that coloured grounds or underlayers may now be more visible than originally intended [21].

Until the nineteenth century, when developments in chemistry produced many new pigments, the range of suitable pigments with the right characteristics was limited. As well as the obvious requirement of intensity and purity of hue, it was desirable that a pigment be as chemically stable as possible, and unaffected by light, moisture, the air and any other factors to which it may be exposed in a painting. Some pigments will react chemically with one another, but are quite stable on their own.

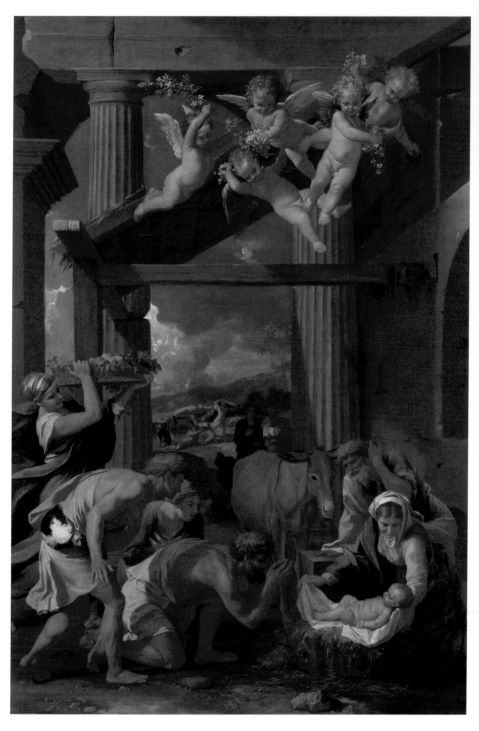

21. Nicolas Poussin, *The Adoration of the Shepherds*, about 1633–4. The ground colour that Poussin employed has become visible over time, as the overlying oil paint layers have become more transparent.

22. Sizes of paint tubes supplied by Bourgeois âiné, 1888.

TARIF N° 3

COULEURS SUPERFINES A L'HUILE
POUR LE TABLEAU

A great variety of coloured materials have been used as pigments. The bulk of these came from the natural world, either as coloured minerals and earths, or as natural products such as dyes and resins obtained from plant and animal sources. From early times in China, Egypt, Greece and Rome, certain manufactured pigments were also used; for example, lead white, verdigris and Egyptian (or Pompeian) blue. Sources of supply were sometimes uncertain, but by early Renaissance times professional suppliers of pigments existed, usually in connection with the preparation of drugs and other medicines; some of these were friars. Importers, alchemists and dyers of textiles were also involved in the pigment trade.

Many of the traditional pigments were prepared from their mineral sources by grinding the colour material on a stone slab or in a bronze mortar. Some pigments were first ground in water to reduce them to a fine powder, then mixed with egg or oil. Prepared oil paints were kept in the studio under water to prevent them drying out, and in the seventeenth and eighteenth centuries, paint was supplied and stored in pigs' bladders. In the early nineteenth century, artists' oil paints were being sold in brass or glass syringes, and in 1841 the collapsible metal tube, made from lead, was devised by John Rand, an American portrait painter living in London.

During the fifteenth century, oil superseded egg tempera as the preferred paint medium in Italy, while a century later, wooden panels gave way to canvas supports. The transition of paint medium was complex, however, and many later fifteenth-century paintings from Italy were painted using both egg and oil paint binder, sometimes mixed together in a medium known as *tempera grassa* (fat, or oily, tempera). There was to be no comparable innovation in colour and pigments until the nineteenth century. However, by the seventeenth century, it had become common for artists to obtain ready-prepared pigments, paints, canvases and other materials from professional suppliers known as artists' colourmen. In the nineteenth century, convenient ready-prepared oil colours in tubes were introduced, and for the first time, commercial manufacture made available paints with reliable tinting strength and handling properties [22].

This, together with the dramatic expansion of the artist's palette, liberated painters from their dependence on traditional pigments, laboriously prepared in the studio, with significant consequences. Jean Renoir quoted his father as saying: 'Without paints in tubes, there would have been no Cézanne, no Monet, no Sisley or Pissarro, nothing of what the journalists were later to call Impressionism.'

The Artist's Palette

Blues

The blue pigments traditionally used for painting exemplify the categories of materials which yielded artists' colours, and also some of the drawbacks associated with the different types. Foremost in quality and reputation was the beautiful brilliant pure blue of genuine ultramarine, a mineral pigment extracted from the semi-precious stone, lapis lazuli [23]. This was used in Europe from the early thirteenth century, when the method of purification was first written down. Its striking colour and great permanence in most media guaranteed its desirability; however, its cost was very high, since until the nineteenth century it had to be imported into Europe from its only known source – the famous mines at Sar-e-Sang, in what is now northeastern Afghanistan. In spite of the high price, ultramarine was quite common in European painting, particularly in Italian medieval and Renaissance works, and especially for the royal blue draperies worn by the Virgin Mary; the colour quality is of such intensity and purity that it is difficult to mistake [24]. Although ultramarine is less often found in northern European paintings, artists certainly used it, then and later, and the skies of Rubens's landscapes are good examples [25].

In order to economise on the use of ultramarine, painters would often lay in an undercolour using a cheaper blue pigment such as azurite, with a layer of ultramarine only at the surface,

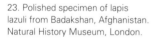

23. Polished specimen of lapis lazuli from Badakshan, Afghanistan. Natural History Museum, London.

24. Masaccio, *The Virgin and Child*, 1426.

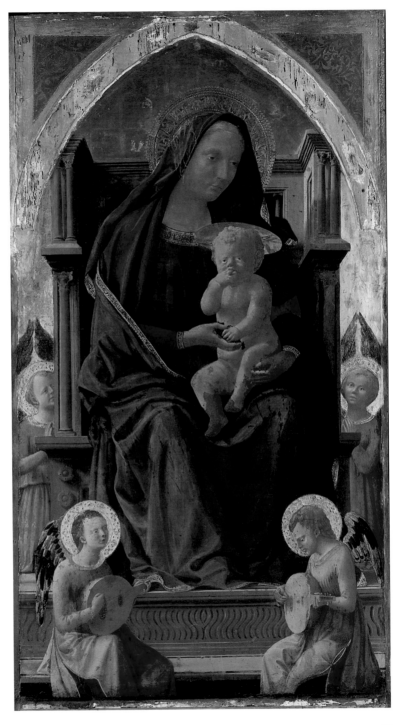

25. (Above) Peter Paul Rubens, *Peasants with Cattle by a Stream in a Woody Landscape* ('*The Watering Place*'), about 1615–22. This detail of the sky shows the brilliance of the ultramarine blue pigment.

26. (Right) Pietro Perugino, *The Virgin and Child with an Angel*, central panel from the Certosa di Pavia Altarpiece, about 1496–1500 (detail). The Virgin's robe is a layer of azurite, with a layer of ultramarine on top – a method of economising on the use of ultramarine.

as in both the sky and Virgin's robe of Perugino's Certosa di Pavia altarpiece [26]. Azurite, another mineral, is more widespread than lapis lazuli; it occurs in Italy, France and Spain, and there are large deposits in Germany and Hungary. It was very widely used in painting until the end of the seventeenth century, when sources of supply in Europe became uncertain. Azurite needs to be coarsely ground for use, otherwise its colour becomes pale, and it usually possesses a distinctly greenish tone, a disadvantage when painting skies [28]. The colour of azurite is perhaps best appreciated in the slightly turquoise blue settings for certain of Holbein's portraits, such as the *Lady with a Squirrel and a Starling* [27].

Two other blues were also used from an early date. Indigo, a dyestuff extracted from plants such as woad and indigo itself, found some role in easel painting, but like most pigments based on natural dyestuffs, it is vulnerable to fading through the action of light. This is unimportant if the work is protected from light: for example, in an illuminated book which is kept closed for most of the time, or where the pigment is used in an underlayer. Indigo at high strength is an intense inky-blue, almost black in tone, and when used in this way, the fading action of light is relatively unimportant since the paint will contain a considerable reserve

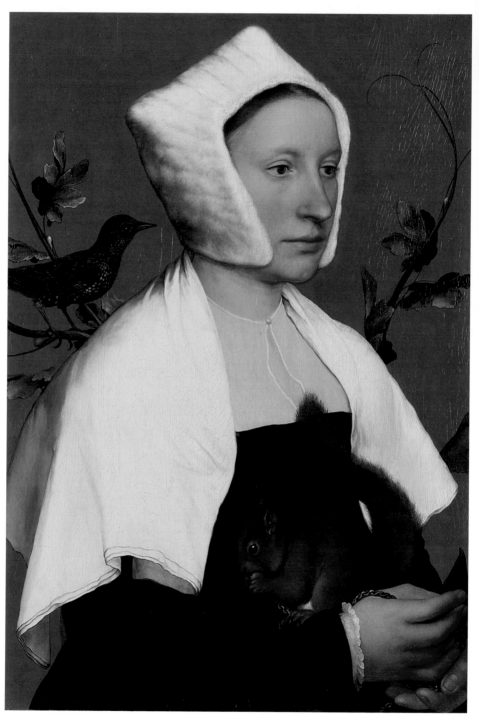

27. (Left) Hans Holbein the Younger, *A Lady with a Squirrel and a Starling (Anne Lovell?)*, about 1526–8. Here the azurite blue background creates an attractive turquoise shade.

28. (Right) Albrecht Altdorfer, *Christ taking Leave of his Mother*, probably 1520 (detail). Only azurite was available to Altdorfer for this picture.

of colour. Some seventeenth-century Dutch artists used indigo in just this manner, as Cuyp did for the dress of the shepherdess in his *Hilly River Landscape* [29].

The fourth traditional blue was a manufactured pigment – a blue glass known as smalt, made by adding cobalt oxide to a potash-rich molten glass, which was then cooled and crushed. As its origin as a glass suggests, it has a pale colour and a poor tinting strength [30]. It suffers other defects as well. Smalt tends to lose its colour with time, particularly in oil, becoming brown or greyish, and this can be seen in the sleeves of ter Brugghen's *Man playing a Lute* [31]. In spite of these faults, it was a standard material in the sixteenth and seventeenth centuries, largely because it was cheap and easy to obtain.

At the beginning of the eighteenth century the appearance of Prussian blue marked a decisive change in the artist's palette. This synthetic pigment was made by chance in Berlin between 1704 and 1710, and its discovery severed the dependence painters had on the traditional pigments, each of which was unsatisfactory, either on account of its cost and scarcity, or its poor colour and unstable nature. As a result Prussian blue, a very powerful intense deep colour similar to indigo, was taken up widely by painters

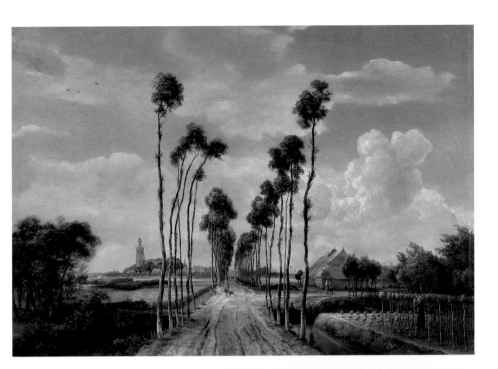

29. (Left) Aelbert Cuyp, *A Hilly River Landscape with a Horseman talking to a Shepherdess*, about 1655–60. Detail showing the shepherdess's dress, painted with indigo.

30. (Above) Meindert Hobbema, *The Avenue at Middelharnis*, 1689.

31. (Right) Hendrick ter Brugghen, *A Man playing a Lute*, 1624 (detail).

These two examples show how the blue smalt pigment has faded.

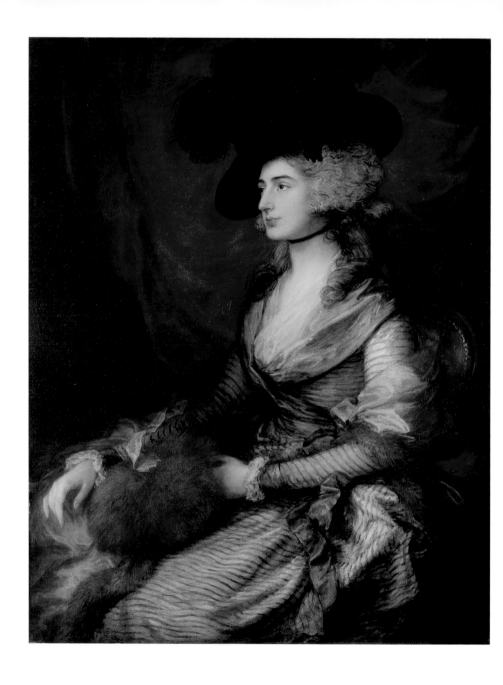

32. Thomas Gainsborough,
Mrs Siddons, 1785.

33. Canaletto, *Venice: The Upper Reaches of the Grand Canal with San Simeone Piccolo*, about 1738 (detail of fig. 79).

34. Claude-Oscar Monet, *Lavacourt under Snow*, about 1878–81.

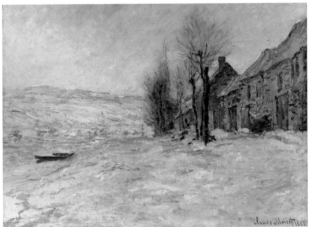

from the 1720s when it became generally available. It can be seen, for example, in Gainsborough's depiction of Mrs Siddons's 'wrapping-gown' [32] or in Canaletto's skies [33].

Around a century later, in 1803, another synthetic blue pigment was invented – cobalt blue – while in 1828, following a competition in France to devise a method of manufacture, an artificial variety of ultramarine (French ultramarine) was produced: a cheap and easily obtainable alternative to the desirable and costly natural ultramarine. The painters of the nineteenth century were thus offered a wide choice of blues, including cobalt blue, a stable and reliable pure, deep blue colour that was greatly admired by the Impressionists [34].

35. Sandro Botticelli, '*Mystic Nativity*', 1500 (detail). The verdigris glaze over gold leaf of the angel's drapery has discoloured.

Greens

Greens are as important components of the palette as reliable blues. No landscapist can work without the colour, and depicting colourful draperies, including those of a rich deep green, has always been important in Western art. Before the nineteenth century, painters had no stable intense green pigment at their disposal. Yet a lack of pigments was less problematic, since green colours can always be mixed from combinations of blue and yellow, and if necessary adjusted in tone by adding other colours – browns, white, black and so on. As with blues, the range of materials was diverse and so was the colour quality. A rather dull olive-green earth colour, terre verte, was widely used as an underpaint for flesh in early Italian tempera paintings, particularly in the fourteenth century and continuing into the fifteenth; the green often shows through the upper layers more strongly than the painter intended, as in the Virgin's face in Duccio's triptych, *The Virgin and Child with Saints Dominic and Aurea* [13, 20].

36. Jan van Eyck, *Portrait of Giovanni (?) Arnolfini and his Wife* ('*The Arnolfini Portrait*'), 1434 (detail, see fig. 65).

Another green mineral pigment, malachite, was also used, but its colour is not particularly strong. Verdigris, a manufactured copper-based pigment, known from ancient times, has a very powerful intense colour, but it can prove unstable, particularly when combined with oils and resins to form a deep green translucent glaze which may prove vulnerable to the action of light. This formerly green glaze is responsible for some of the deep orange-browns seen in the landscape backgrounds of many Italian paintings of the fifteenth and sixteenth centuries, and is a colour change that sometimes also afflicts draperies [35]. In other contexts, as in the woman's dress in van Eyck's *Arnolfini Portrait*, verdigris can survive for centuries in beautiful condition in oil paint [36]. Nineteenth-century developments provided painters with new, reliable synthetic green pigments of intense colour, such as emerald green (a poisonous pigment containing copper and arsenic) and viridian (a chromium oxide), favoured by Cézanne, Renoir and Monet [37, 38].

39

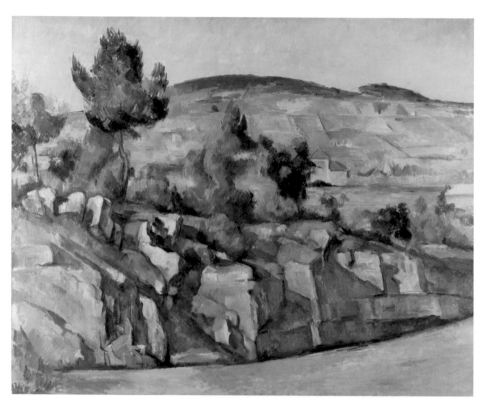

37. (Above) Paul Cézanne, *Hillside in Provence*, probably about 1890–2.

38. (Right) Claude-Oscar Monet, *Bathers at La Grenouillère*, 1869 (detail, see fig. 81).

These paintings show the application of viridian, a green pigment new in the nineteenth century.

39. Masaccio, *Saints Jerome and John the Baptist*, probably 1428–9 (detail). The robe of Saint Jerome retains the brilliant rich red of vermilion.

Reds

Reds are also indispensable for all painters. From early times a bright scarlet colour, vermilion, was obtained by pulverising a mineral, cinnabar. From the ninth century in Europe, synthetic vermilion, a compound of mercury and sulphur, was also made [39]. Both types of vermilion are dense, opaque and of a clear brilliant hue, although liable to darken or develop a purplish-grey surface sheen in some paintings, particularly those in egg tempera. A panel by Uccello shows this unfortunate phenomenon most strikingly [40].

However, because of its opacity, vermilion cannot be used for glazing, which calls for a translucent pigment such as a red lake. Lake is the name given to a range of pigments based on dyestuffs obtained from both plant and animal sources. The most familiar modern example is probably cochineal, a deep purplish-red dye derived from a Mexican scale insect. Lac and kermes are two other insect sources of red dyestuffs, and there are also plant dyes extracted from brazilwood and the madder plant. The overriding characteristic of lakes is their translucency, particularly in oil paint – their powerful, saturated deep colours were often used to depict rich fabrics and draperies by glazing red lakes over more solid undercolours, sometimes a lake mixed with lead white or vermilion. Venetian sixteenth-century painting provides some of the best examples [41], but the technique was used in all periods of painting. All lakes, which can be made in yellow varieties as well as reds, are vulnerable to fading through the action of light [42].

40. (Left) Paolo Uccello, *Niccolò Mauruzi da Tolentino at the Battle of San Romano*, probably about 1438–40. This detail shows how the vermilion paint used for the horses' bridles has heavily discoloured.

41. (Below) Titian, *The Vendramin Family, venerating a Relic of the True Cross*, begun about 1540–3, completed about 1550–60 (detail).

42. (Right) Thomas Gainsborough, *Dr Ralph Schomberg*, about 1770.

41 and 42 both show the figures wearing garments painted in red lake. However, the coat in the Gainsborough has suffered through the action of light.

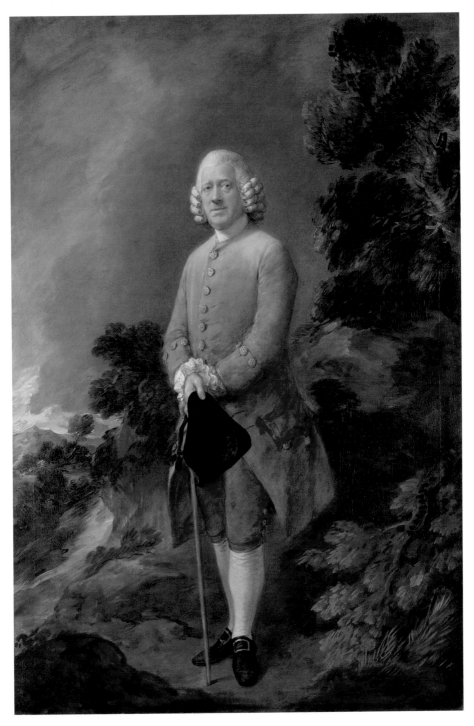

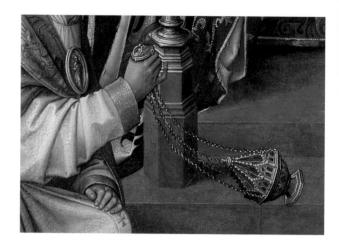

43. Workshop of Rogier van der Weyden, *The Exhumation of Saint Hubert*, late 1430s (detail). The 'gold' of the censer is in fact successfully rendered in yellow paint – not gold.

44. Raphael, *The Crucified Christ with the Virgin Mary, Saints and Angels* ('*The Mond Crucifixion*'), about 1502–3 (detail).

Yellows

Before the nineteenth century, opaque strong yellow colours (apart from yellow ochres, which were extracted from naturally occurring earths) were manufactured. The most important of these traditional artificial yellow pigments is known as lead-tin yellow, and is made by firing the oxides of lead and tin in a furnace to over 800 °C. This produces a pale primrose or deep daffodil-coloured powder which forms a reliable dense and opaque pigment: two distinct varieties of this pigment were made historically and their technology of production was interrelated. Lead-tin yellow was used from the fourteenth century in tempera and later in oil, often to depict gold highlights on painted textiles and the glint of metallic gold on objects made of the metal. The technique was especially well developed in early Netherlandish painting [43].

Yellow draperies were often worked in lead-tin yellow paint [44] and the pigment mixed with others, particularly azurite and verdigris, was used for landscape and foliage greens. The method of manufacture of lead-tin yellow appears to have been lost towards the end of the seventeenth century and a modified form of lead-based yellow, containing antimony rather than tin, became the standard material. This was known as Naples yellow, and tends to have a warmish or pinkish yellow tone, less clean and bright than lead-tin yellow [45]. By around 1820 a whole range of new yellows began to be manufactured, based on compounds of the metal chromium, of which chrome yellow (lead chromate) is the archetype. These pigments and, rather later, cadmium yellow became the most important yellows of the nineteenth-century artists' palette and later [46]. Turner's use of chrome yellow, for example, was prolific [47].

45. Thomas Gainsborough,
*The Painter's Daughters chasing
a Butterfly*, probably about 1756
(detail). This dress is painted in
Naples yellow.

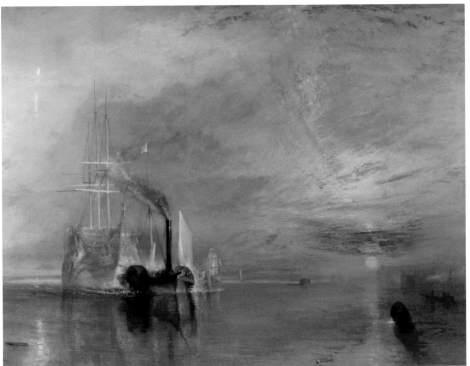

46. Claude-Oscar Monet, *Water-Lilies*, about 1916, showing his use of cadmium yellow.

47. J.M.W. Turner, *The Fighting Temeraire tugged to her Last Berth to be broken up, 1838,* 1839. The memorable sunset is painted in chrome yellow.

48. Rembrandt, *A Woman bathing in a Stream (Hendrickje Stoffels?)*, 1654. This panel painting has an earthy palette of reds, browns, yellows and white.

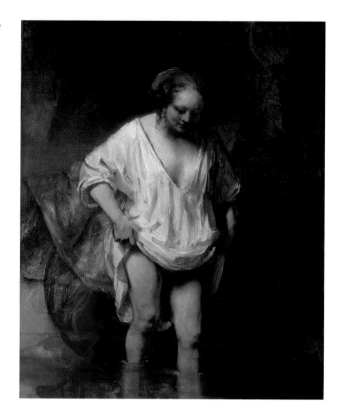

Whites, Browns and Blacks

The essentials of the palette are provided by blue, green, red and yellow pigments, plus white and black. But as well as these powerfully coloured, high-key pigments, more sombre colours played important subsidiary roles in recessive passages, or in mixtures with other colours. Natural earths – ochres, siennas and umbers – provide the painter with a range of more muted colours from yellow, yellow-brown and orange through to red, dark brown and virtually black – varying in their degree of translucency as well as in colour. Many of Rembrandt's paintings, for example, make considerable use of these natural earths, combined with other pigments, particularly white and black [48]. Towards the end of the eighteenth century, synthetic versions of some of these earth colours had also become available.

The principal white pigment used by painters from early times was a synthetic and poisonous lead compound – lead white – formed as a white corrosion crust on metallic lead exposed in closed vessels to sour wine (acetic acid) in the presence of carbon dioxide. This dense, opaque white was used in all periods and

49. Frans Hals, *Portrait of a Man in his Thirties*, 1633 (detail). The brilliant white ruffled collar is painted in lead white.

techniques up to the twentieth century, when it was replaced by non-poisonous whites made from zinc, and later from titanium. The well-preserved condition of many passages of pure white in easel pictures indicates the high stability of lead white in oil paint [49].

Most black pigments come from natural sources, although some processing or preparation may be involved. The majority are based on pure carbon: charcoal from various woods and plants (willow, beech, vine twigs, peach stones and so on); carbonised bone and ivory blacks; mineral types of carbon such as coal, black chalk and graphite; and lampblack, essentially soot. All these materials are chemically very stable, and the poor condition of passages of black paint on many old pictures is due more to the poor drying qualities of the pigments in oil, rather than to any inherent instability. It has been discovered recently that certain metallic pigments were used in Renaissance times to form grey paints when mixed with white: examples include the heavy metal bismuth and metallic antimony as well as its sulphide mineral (stibnite).

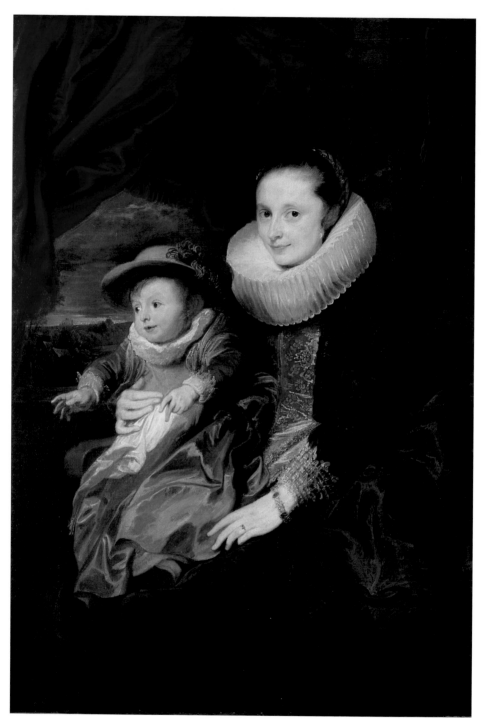

Identification of Pigments

50. Anthony van Dyck, *Portrait of a Woman and Child*, about 1620–1.

51. This microphotograph shows the paint surface from the child's dress in fig. 50. The paint is made of red lake, charcoal black and white.

It would be satisfying to be able to look at a picture and know, by sight alone, what made up the artist's palette. Unfortunately, while it is possible to make an educated guess, no purely visual assessment is entirely reliable. Discoloured varnish distorts the colours beneath, affecting some colours more than others, particularly whites and pale or mid-blues; some pigments may have changed by discolouration, darkening or fading. Other pigments may be mixed together in the paint layers so that their individualities as colours are hidden. However, microscopical or chemical analysis of the materials used, supported by research into their history of use and their known characteristics, does provide definite identification and it is proving increasingly possible to perform so-called 'non-invasive' analysis of the surface layers on paintings without the need of physical samples. Sometimes the conclusions of identification can be quite surprising, as in the pigments used for the beautiful bluish-purple dress worn by the child in Van Dyck's *Portrait of a Woman and Child* which contains a mixture of red lake with charcoal black mixed with white; no blue pigment is present at all [50, 51].

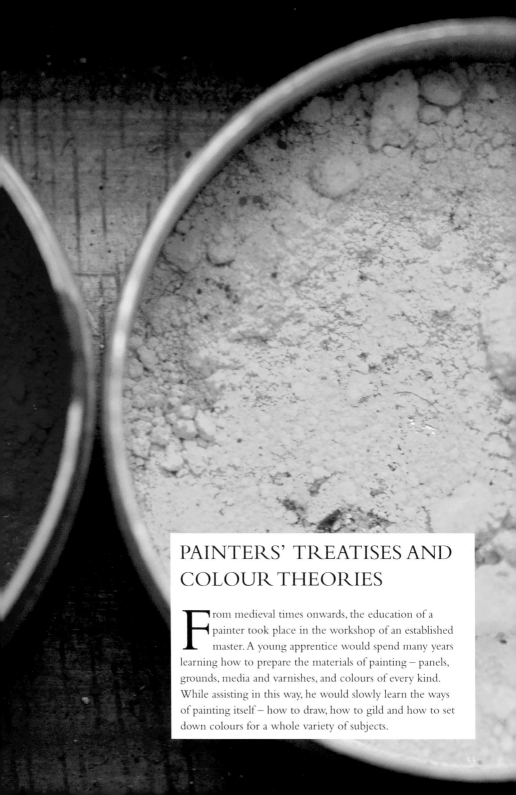

PAINTERS' TREATISES AND COLOUR THEORIES

From medieval times onwards, the education of a painter took place in the workshop of an established master. A young apprentice would spend many years learning how to prepare the materials of painting – panels, grounds, media and varnishes, and colours of every kind. While assisting in this way, he would slowly learn the ways of painting itself – how to draw, how to gild and how to set down colours for a whole variety of subjects.

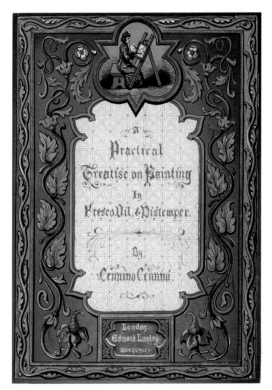

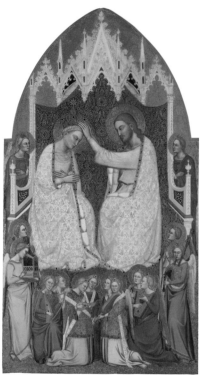

Handbooks and Instruction Manuals

52. Title page of *Il Libro dell'Arte* (*The Craftsman's Handbook*), nineteenth-century edition, by Cennino Cennini.

53. Jacopo di Cione, *The Coronation of the Virgin: Central Main Tier Panel*, 1370–1.

Knowledge of painting practice was transmitted from master to pupil and from workshop to workshop by tradition and example. Occasionally – rarely at first, but more commonly in later centuries – painters would write down their methods in the form of handbooks or instruction manuals. These documents are fascinating to us for the light they shed on the painting techniques of a particular period – and we make careful comparisons between the information they contain and present-day technical studies of paintings from the same era. But it is also worth remembering that painting treatises might be highly specific in their aims – often practical and down-to-earth, sometimes theoretical and philosophical – but always of their time, set against particular social, political and economic backgrounds and illustrating specific repertoires of artistic ambition.

The most famous painters' handbook in European art, written around 1390, is *Il Libro dell'Arte* (*The Craftsman's Handbook*) by the Tuscan painter Cennino Cennini [52]. The methods he described,

in great practical detail and in wonderfully everyday language, are those of the earlier fourteenth-century tradition in which he worked. One of *The Craftsman's Handbook*'s central themes is the use of colour, described as 'the glory of the profession' and we are informed 'which are the choicest colours, and the coarsest, and the most fastidious; which one needs to be worked up or ground but little, which a great deal; which one calls for one tempera, which requires another...' Cennini's text is full of practical advice on the preparation of the raw materials of painting and on 'how to make draperies in blue and purple', 'how to paint a dead man', 'how to paint water', and so on. It sets down clear systems of colour for depicting almost everything a late medieval painter might need to include in a painting. Importantly, they were systems devised for painting in fresco and egg tempera – opaque, quick-drying media that were used in simple, direct techniques.

For painting faces, for example, Cennini instructed that the flesh first be underpainted with the pale green earth colour, terre verte. The pink skin tones were then hatched or thinly painted on top, as the artist worked in increasingly paler shades from shadow to light. The underlying green was allowed to show through in the half-tones, cleverly imitating the pearly colour of real flesh [13, 20].

Cennini was also specific about painting coloured draperies. Colours were used in their pure form in the deepest shadows and lightened progressively with white towards the lit areas, finishing with highlights of pure white. For its time, this was a successful formula but, as the demand for realistic representation evolved, its drawbacks became apparent. The main problem with it was that by placing the most powerfully saturated colour in the deepest shadows and then desaturating it towards the lights, the shadows often seemed to advance and the lights to recede [53].

Theories and Treatises

Cennini's handbook reflected the art of the past, and the techniques it described were the culmination of medieval practice, but there is no evidence that it was read outside the painter's workshop, and it remained unpublished until the nineteenth century. Forty years after Cennini, Leon Battista Alberti's *Della Pittura (On Painting)* of 1435–6, the first important theoretical treatise on painting of the Italian Renaissance, anticipated the new order in art – an art in which human hierarchies as well as religious ones began to assume significance in the painter's

54. Cosimo Tura, *The Virgin and Child Enthroned*, central panel from the so-called Roverella Altarpiece, mid-1470s. This painting shows green, rose and sky-blue paint used as prescribed by Alberti.

depiction of the world [54]. Painters took on new challenges, attempting to grapple with ever more realistic representations of the world around them, exploring landscape, light and recession. *On Painting* changed representational art for ever with its revolutionary description of single-point perspective, for drawing three-dimensional space on a two-dimensional surface.

Alberti's book was quite different from Cennini's. It was the first modern analytical study of painting – a treatise on the theory of art, not an instruction manual. It was not a handbook written in the vernacular for use in the workshop, but a scholarly book written for a literate audience. It does consider the artist's use of colour, but Alberti was much less interested than Cennini in individual pigments or colour effects and more in the depiction of form defined by light and shade. Whereas Cennini gave practical hints for mixing and combining colours, Alberti explored the idea of colours that enhance each other when placed together – a phenomenon that, centuries later, developed into a theory of complementary colours: '...there is a certain friendship of colours so that one joined with another gives dignity and grace.' One example Alberti gives, '...rose near green and sky blue...' is echoed precisely in the Roverella Altarpiece by Cosimo Tura [54], although it is probable that Tura arrived at this radiant combination quite independently of the theories of Alberti.

'Disegno' and 'Colore'

In the writings of Giorgio Vasari and later authors, a fundamental question was posed. Which was more important in painting, drawing or colour – *disegno* or *colore*? Vasari, author of *The Lives of the Artists*, published in 1550, was in no doubt: as a Florentine, he championed the art of *disegno* as evidenced by the work of Michelangelo. In his *Life of Titian* he described a conversation with Michelangelo about Titian's method in some paintings they had just seen: 'Buonarroti commended it highly, saying that his colour and style pleased him very much, but it was a shame that in Venice they did not learn to draw well.' Vasari was especially scathing about Giorgione, another Venetian painter, who, he said, 'failed to see that, if he wants to balance his composition...he must first do various sketches on paper to see how everything goes together.'

The opposition of *disegno* and *colore* was more complex than simply drawing versus colour. Michelangelo, the most celebrated exponent of *disegno*, was also capable of astonishingly vivid colour,

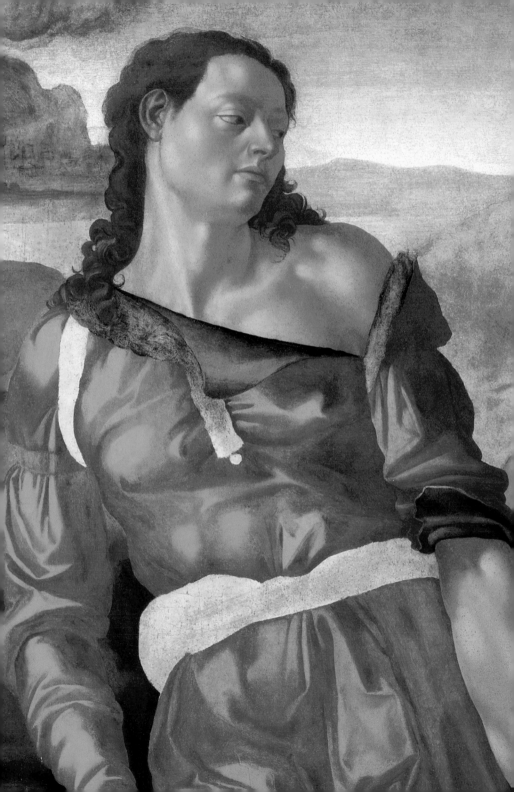

55. Michelangelo, *The Entombment*, about 1500–1 (detail).

56. Titian, *Diana and Actaeon*, about 1556–9. Bought jointly by the National Gallery and National Galleries of Scotland with contributions from The Scottish Government, the National Heritage Memorial Fund, The Monument Trust, The Art Fund and through public appeal, 2009.

Michelangelo was a great exponent of *disegno*: his compositions are carefully drawn and then colour is added. Titian, on the other hand, often created his compositions directly on the canvas, making superb use of *colore*.

as can be seen from the restored ceiling of the Sistine Chapel, and the controversy it has provoked, or the more finished areas of the National Gallery's *Entombment* [55]. In this opposition rather, it is the method of creation that is significant: planning and formal preparation were the requisites of *disegno*; Titian's habit of evolving his compositions directly on the canvas – especially in his later works – was the essence of *colore* [56]. In the late seventeenth and early eighteenth centuries, arguments raged in the French Academy and elsewhere, and famous discourses took place between the Rubénistes (for colour), and the Poussinistes (for drawing).

These were intellectual battles that had more to do with spontaneity against formality than with colour against drawing. The eventual result was a scholarly acceptance of artistic freedom and the use of colour in ever bolder techniques, culminating in the Romantic painters of the nineteenth century and the Impressionists.

OPTICE:

SIVE DE

Reflexionibus, Refractionibus, Inflexionibus & Coloribus

LUCIS

LIBRI TRES.

Authore ISAACO NEWTON, Equite Aurato.

Latine reddidit *Samuel Clarke*, A. M. Reverendo admodum Patri ac Dno JOANNI MOORE Episcopo NORVICENSI a Sacris Domesticis.

Accedunt Tractatus duo ejusdem AUTHORIS de Speciebus & Magnitudine Figurarum Curvilinearum, Latine scripti.

LONDINI:
Impensis SAM. SMITH & BENJ. WALFORD, Regiæ Societatis Typograph. ad Insignia Principis in Cœmeterio D. Pauli.
MDCCVI.

Optical Theories

By the nineteenth century, painters interested in colour theory increasingly turned to scientific treatises, beginning with Isaac Newton's *Opticks, or, A Treatise of the Reflections, Refractions, Inflections & Colours of Light* (1704) [57]. It was Newton who had first demonstrated that white light could be separated into pure prismatic colours and that those colours could be re-combined to make white light again. This was an extraordinarily powerful concept for painters concerned with the depiction of the effects of light and the colours of the natural world – but the full force of these theories did not impinge on painting practice until well into the nineteenth century. Newton also systematised colours: colour diagrams were not new – they had been known since the fifteenth century – but Newton arranged the colours of the spectrum in a circle that placed complementaries opposite each other. Complementaries are pairs of colours that cancel each other out when mixed, to produce white if they are coloured lights and grey if they are coloured paints [58].

The legacy of Newton's colour theories was a proliferation of scientific and quasi-scientific texts in the nineteenth century; for example, the extensive account of the range and stability of artists' materials offered by George Field in his *Chromatography, or, A Treatise on Colours and Pigments: and of their Powers in Painting*, published in England in 1835 [59]. Three further sources that were particularly influential on painters were the writings of Michel-Eugène Chevreul, director of dyeing at the Gobelins tapestry workshop, Charles Blanc's *Grammaire des arts du dessin* (*Grammar of the Arts of Drawing*, 1867) and Ogden Rood's *Modern Chromatics* (1879). Chevreul formulated laws of simultaneous

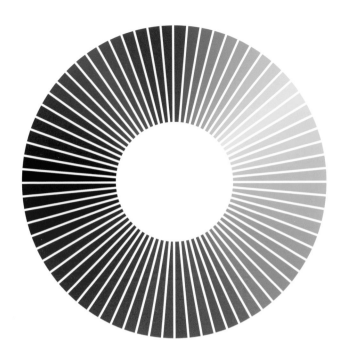

59. Page from George Field's
Chromatography, 1835.

60. Michel-Eugène Chevreul's
colour circle, divided into 72
sectors.

contrast which, among other things, stated that complementary colours, opposites on the colour wheel, enhanced each other when placed side by side [60]. This was something that had been instinctively understood since Alberti's 'friendship of colours'. Leonardo da Vinci had described the most beautiful colour contrasts as being those of opposites. But it was Chevreul's work that influenced painters consciously to juxtapose complementaries in order to achieve powerful interactions of colour. However, Chevreul warned that colours that mutually enhance each other can also cancel each other out if too intimately mixed: as an example, he wrote of threads in a tapestry that would appear merely grey if adjacent complementaries were too closely woven. The use of complementary colours was crucial to the art of Delacroix (described by Charles Blanc as 'one of the greatest colourists of modern times') and subsequently became a key to much Impressionist and Post-Impressionist practice. It manifested itself in two principal ways. Firstly, some of the most vibrant paintings of Delacroix and the Impressionists are based on the simultaneous contrast effect, with direct orange–blue, red–green or yellow–violet complementary pairings [61, 62]. Secondly the tinting of shadows with the complementary of an adjacent highlight – as noted by Delacroix in his journal

61. Eugène Delacroix,
Christ on the Cross, 1853 (detail).

62. Pierre-Auguste Renoir,
The Skiff (La Yole), about
1875 (detail).

(see p. 14) – mimicked the physiological behaviour of the human eye, fatigued by exposure to bright colour. Coloured shadows are often seen in Impressionist paintings: they were usually blue-violet in contrast to orange-yellow sunlight and their widespread use led to the Impressionists being diagnosed with the imaginary affliction of 'violettomania' by derisive critics.

Neo-Impressionist paintings – particularly the work of Seurat that came after his *Bathers at Asnières* (p. 92) – represent a problem for the student of colour theories. Based on the writings of Chevreul, Blanc and Ogden Rood, the premise of their technique of 'chromo-luminarism' was that it imitated the very behaviour of light itself – that dots of pure spectral colour would re-form into the colours observed in nature with a brilliance and luminosity unobtainable with conventional pigment mixtures. Colours would blend in the eye and not on the palette, a technique that came to be known as Pointillism. In practice, though, dots of coloured paint do not behave like points of coloured light and Chevreul's warning that complementaries could mix to make grey became a real problem. Recent studies have indeed questioned the scientific basis of Seurat's technique. Moreover, it was extraordinarily laborious and inhibited artistic freedom – which is why Pissarro's experimentation with it was comparatively brief. Nevertheless, despite the technique's limitations, its painstaking formality and the uncalculated greyness shimmering around the points of colour, Seurat produced some of the most haunting images in European art [63].

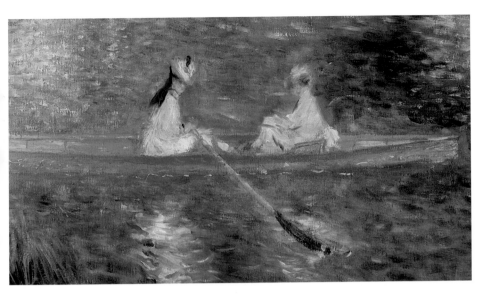

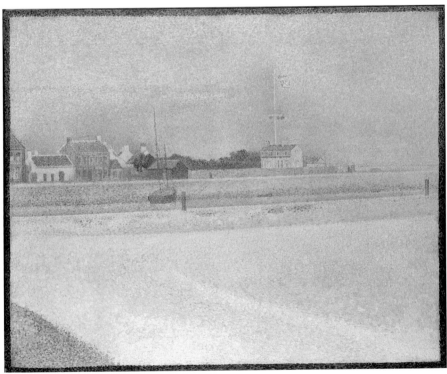

63. Georges Seurat, *The Channel of Gravelines, Grand Fort-Philippe*, 1890.

THE PAINTER'S USE OF COLOUR

We have already considered how the painter's palette was influenced by factors such as the suitability of available materials, cost, or conventions for painting certain subjects. Looking at the pictures themselves enables us also to understand the subtle or sometimes surprising ways in which artists have used colour to achieve different effects; by varying or combining the pigments at their disposal and by mixing them with different binding media. They show the importance of the layer structure of paintings – for example, how the use of light or dark grounds fixed the overall tonality of a painting and determined the way a painter set down his colours. The layering of different colours – warm, dark glazes over lighter underpaints, or cool, light 'scumbles' over darker paint – was exploited by painters to extend the possibilities of colour beyond the straightforward use of pigments on their own or in conventional mixtures. The calculated placing of certain colour combinations within a composition added further dimensions to a painter's aims, mimicking or triggering recognisable perceptual responses in the viewer or conveying symbolic meanings.

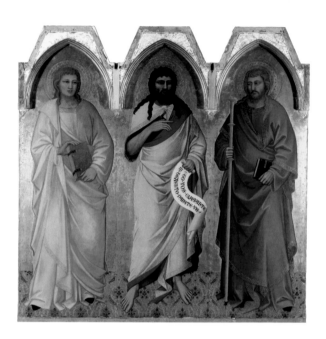

Cennino Cennini's Technique Exemplified

Nardo's altarpiece, *Saint John the Baptist with Saint John the Evangelist(?) and Saint James* [64], painted around 1365 for the church of San Giovanni Battista della Calza in Florence, is a fascinating example of the type of craftsmanship detailed in Cennini's *The Craftsman's Handbook*. Many of the technical features of Nardo's painting – especially his use of colour – correspond almost exactly to Cennini's descriptions.

After preparing the panel according to standard fourteenth-century practice, and marking out the design, the gilding of the background and the tooling or punching of the haloes were carried out. Nardo then went on to make the sumptuous gold brocade carpet on the floor. Cennini describes the process in detail: 'I want to show you how to make a cloth of gold...' The first stage was to paint a solid layer of the principal colour over the gold: '...lay in with vermilion over the burnished gold.' (In fact, the orange colour in Nardo's painting is red lead, a pigment that Cennini was wary of because of its tendency to turn black.) Next, the design of birds and flowers was marked out on the red colour, using a simple repeat paper stencil, and the ultramarine blue details were added on top. The gold was then

carefully exposed within the outlines of the pattern by gently scraping: '...when you have pounced your cloth, take a little stylus of hardwood or bone...and scrape and remove the colour nicely, so as not to scratch the gold.' The final stage was to punch the exposed gold with a fine pattern of indented dots to give a shimmering effect to the brocade: '...whatever you uncover, stamp afterward with...a single little iron punch.'

Nardo's painting of draperies also corresponds closely to Cennini's recommendations. The pink drapery of Saint John the Baptist, for example, consists of a pure red lake pigment in the deepest shadows, lightened progressively with white towards the lights, exactly as Cennini describes: '...always start doing the draperies with lac... in its own colour...and [then] take two parts of lac colour and a third of white lead...and [then] step up three values from it...' These pre-prepared shades would then be used to construct the forms of the drapery, beginning with the shadows and moving systematically towards the lights. The blue drapery is similarly constructed, moving from deep shadows of pure ultramarine to lights of blue and increasing amounts of lead white. In addition, Nardo seems to have used different qualities of ultramarine to give different intensities of blue. The saint at the left wears a green *cangiante* or 'shot' drapery – another type of colour effect that Cennini described at length – in this case it is wrought from varying proportions of ultramarine and lead-tin yellow. Cennini mentions a number of colour combinations suitable for *cangiante* fabrics but none of them quite corresponds to that seen here. The middle tone is an unusual almond green shade, the shadows blue and the highlights a pale yellowish green.

The flesh painting in the altarpiece was also carried out according to the Cennini recipe: as with drapery, three values (shades) of flesh colour should be prepared, each containing a higher proportion of lead white than the last, laying each on the face according to the modelling but letting 'the green which lies under the flesh colours always show through a little'.

In one of the best-known passages of *The Craftsman's Handbook*, Cennini describes how different types of flesh should be painted – suggesting that for a young person of fresh complexion, the yolk of a town hen should be used because it is paler, while for aged and swarthy persons the yolk of a country egg is good because of its redness. It is possible that the remarkable correspondence between Cennini's handbook and Nardo's altarpiece extends even to this rather fanciful suggestion, but even the most modern analytical techniques – unfortunately – cannot confirm this distinction.

The Effect of the Paint Medium

What is undoubtedly true, however, is that the choice of medium had a profound influence on a picture's appearance, even when the artist's palette remained virtually the same. Certain pigments only show their fullest translucent, glowing quality when they are mixed with a medium of oil. Where these are applied as a final surface layer of paint – as a glaze – they produce a glossy, rich effect in the paint that is possessed of great depth of colour; an effect which it is generally not possible to achieve in egg tempera. The technical description for this is 'saturated colour'.

Writing over 100 years after the death of Jan van Eyck, Vasari recorded 'John of Bruges' as the inventor of oil painting – he was referring to van Eyck. Although this is well-known as a myth in the history of painting technique – oil painting was known long before the early fifteenth century – van Eyck and some of his contemporaries brought the practice of oil painting to an extraordinarily high level of refinement and brilliance of execution, as *The Arnolfini Portrait*, painted in 1434, demonstrates [65, 66]. What was seen as so new in this type of painting, on wood panels, was the unparalleled translucency of the paint and its detailed, meticulous application. Many later writers have assumed that the translucency of the paint must have relied on the application of very many thin layers of glaze – that is, of transparent paints – over a more solid, optically dense underlayer. Recent examination of pictures shows that the technique is less elaborate than was once supposed, and although glazes play an essential part in determining the look of these pictures, most

often only single, translucent surface layers are actually present.

Two areas of the Arnolfini double portrait rely on the extensive application of a surface glaze: the rich green fabric of the woman's ermine-trimmed gown and the deep red hangings of the imposing bed and chair behind her. The powerful green of the pigment verdigris, when used in oil, produces a deep glaze of saturated colour, and this is the glaze van Eyck applied over a more solid green underpaint based on verdigris mixed with white, to create the beautiful deep green of the woman's drapery. Remarkably, only a single layer of glaze has been used, and the astonishingly detailed structure of the fabric, with its folds, loops and stitches and its shadows and highlights, was achieved by manipulating the wet paint with the brush rather than by a laborious build-up of each detail in many successive stages. The red of the draperies used for the bed is based on a similar – and deceptively simple – treatment of the paint. The deep, saturated colour relies once more on a pigment which becomes translucent in oil, and is of an intense red colour. Here the surface glaze contains a lake pigment based on a red natural dye material which would have been obtained from a plant or insect source. As with the green draperies, the quality of this red pigment in the oil medium gives a glossy depth of colour to the paint, the richness of which is dependent on the translucent surface glaze applied over a layer of opaque, bright red, vermilion.

Other traditional water-based media such as gum, glue or egg white, continued to be used in various forms, including manuscript illumination and other works on paper. Two paintings in the National Gallery by the fifteenth-century artist Bouts, each executed in different media, provide a vivid illustration of the effect of the paint medium on the appearance of colours. *The Virgin and Child* [67], painted around 1465, is an oil painting in the direct and relatively new tradition of van Eyck and Rogier van der Weyden. It is painted on an oak panel prepared with an ivory-smooth white ground, in colours made rich and glowing by the use of linseed oil. The glossy oil medium saturates the pigments and renders some of them translucent, permitting the use of glazes – transparent, warm coloured paint layers over lighter opaque underpaints. In addition, its slow-drying properties allowed great subtlety in the blending of tones: transitions from light to shade could be made imperceptibly gradual or dramatically sharp with equal ease.

The Entombment, probably dating to the 1450s, is a rare surviving example of a type of painting known as *Tüchlein* in which the support is fine linen and the pigments are leanly bound

67. Dirk Bouts, *The Virgin and Child*,
about 1465.

68. Dirk Bouts, *The Entombment,*
probably 1450s.

69. X-ray image of the Virgin's face in fig. 68.

in glue – that is, the ratio of medium to pigment is low [68]. This was a technique that derived from the medieval painting of banners and ephemeral decorative schemes, using a combination of materials that was fragile and impermanent. *The Entombment* is among the best preserved *Tüchlein* now in existence, although much faded. It has never been varnished, which would have darkened and saturated the colours irreversibly.

The appearance of this type of painting is pale, dry and chalky and this is a direct result of the optical and physical properties of the glue medium. Glue does not saturate or wet colours in the way that oil does – and pigments that appear dark, glossy and translucent in oil are light, matt and opaque in glue. A particularly striking demonstration of this effect is the widespread occurrence of chalk in the paint layers of *The Entombment*. Normally, chalk is quite useless as a white pigment: in oil or egg it forms a translucent cloudy mixture with almost no covering power. Bound in glue, however, it dries to a perfectly satisfactory white paint. Lead white also occurs in the painting – and, curiously, both pigments are used for separate parts of the white cloth around the Virgin's head. The part below her chin shows white in an X-ray, indicating the presence of the dense lead white, while the part on top of her head is dark, indicating the use of chalk – and yet, to the unaided eye, both passages appear the same [69].

The basic palettes of the two paintings are broadly similar – azurite, ultramarine, vermilion, red lake, lead-tin yellow, earth pigments, lead white. The greens differ (verdigris in *The Virgin*

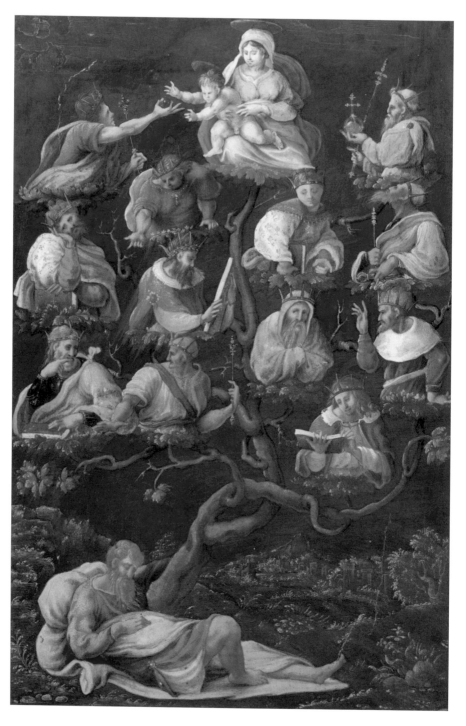

and *Child* and malachite in *The Entombment*) and the occurrence of chalk is obviously specific to the glue painting. But *The Entombment* is remarkable in having no fewer than four blue pigments. As well as azurite and ultramarine, the Virgin's robe and Nicodemus' collar also contain smalt. The use of three blue pigments in a single paint mixture is highly unusual and the occurrence of smalt in a painting of this early date is notable.

The fourth blue present in the painting is indigo – which, with lead-tin yellow, forms the blue-green of the landscape. Indigo fades when exposed to light and that this landscape (and indeed the whole painting) was once much more colourful is evident from a bright turquoise strip at either side, where the painting has been protected from the light in a previous smaller frame. In contrast, the relatively unfaded *A Jesse-Tree*, attributed to Girolamo Genga, demonstrates how vivid colour could be in a water-based medium (probably gum or egg white, in this case, on parchment or paper) [70].

Unusual Pigments

Venetian painting in the sixteenth century is especially famous for the intensity and vibrant power of its colour. Colour was of central interest to the painters of Venice, and the city – one of the most significant trading ports of Europe, and an important centre for textiles and glass-making – was well placed to provide a great range of precious imported pigments from the East and elsewhere. Titian's *Bacchus and Ariadne* (1520–3) is a striking example of spectacular colour, using imported and unusual pigments [71]. The intense blue of the sky is painted in natural ultramarine extracted from imported lapis lazuli [23]; so too is Ariadne's drapery and that of the Bacchante with the cymbals, as well as the flowers of the small irises at the lower right. It is the most extensively used blue in the picture, with azurite displaying its greener tone to describe the colour of the sea in the background. Another brightly coloured pigment, vermilion, is responsible for the scarlet of Ariadne's sash, while an intense red lake used in glazing Bacchus' fluttering drapery contrasts with the deep blue sky behind. This red lake, probably made from an insect dyestuff, is quite purple in tone, with a translucent and saturated appearance when compared to the opaque, dense paint of Ariadne's brilliant red sash. The preparation of these beautiful and costly red lake colours was a speciality of Venice, and was often a by-product of textile dyeing.

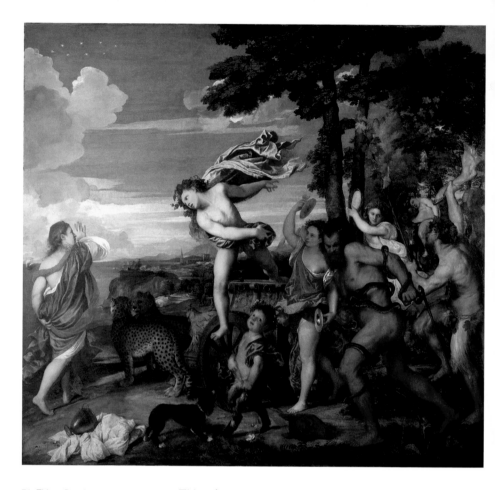

71. Titian, *Bacchus and Ariadne*,
1520–3. Venetian painters could
obtain fine pigments because
Venice was a major port city.

72. Detail of fig. 71, demonstrating
the use of the rare pigment realgar
on the Bacchante's drapery.

Titian chose a rare arsenic-containing orange mineral known
as realgar, also imported, for the Bacchante's drapery [72], where
it makes a powerful contrast of complementary colour with the
ultramarine of the lower section of drapery.

Titian further exploited contrasting colour combinations by
placing together a triad of primary colours, opposing the brilliant
red and blue of Ariadne's draperies with the primrose-coloured
cloth beneath the toppled urn, painted in lead-tin yellow.

Less forceful earth colours of yellow, brown and red provide
the more recessive passages and the setting for the principal
players in the scene, with the stronger greens of landscape and
foliage made up of malachite and green resinous glazes. Some of
these glazes have become browner with age, but Titian's depiction
of the rust-coloured foliage of the tree in the upper right is
intentional, since here the paint layers contain earth pigments.

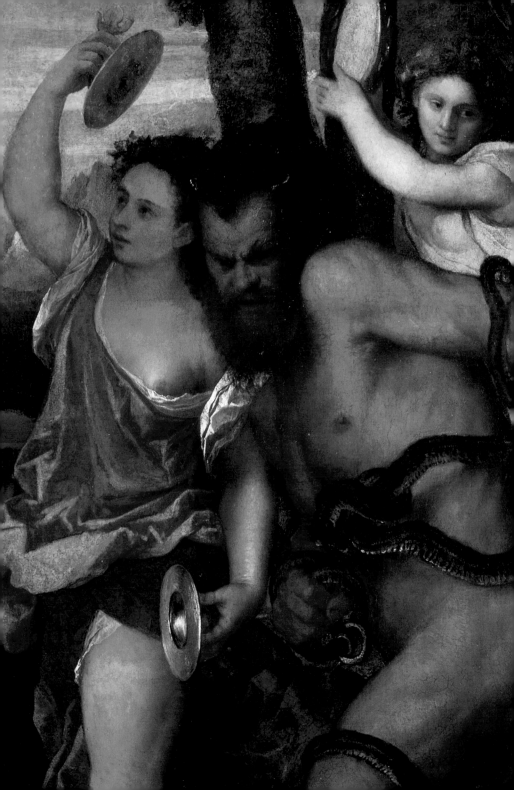

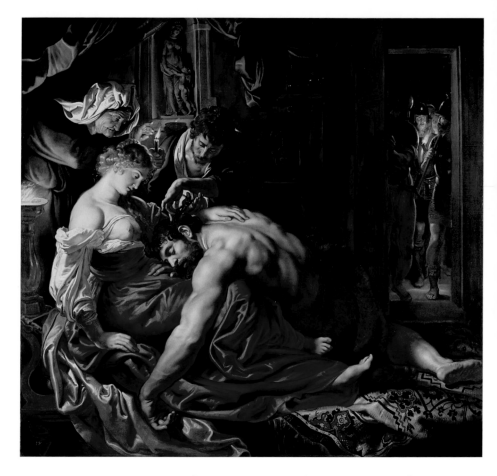

The Seventeenth-century Palette

The study of paintings by seventeenth-century artists such as
Rubens, Velázquez and Rembrandt reveals that although they
used a limited range of pigments, they were able, through optical
means, and the sophisticated manipulation of the oil medium,
to create a variety of subtle colour effects.

Rubens's *Samson and Delilah*, painted around 1609-10, is a
grand composition [73], typical of Rubens's forceful painterly
manner of the period immediately following his return to
Antwerp from Italy. It was commissioned by the Antwerp
burgomaster Nicolaas Rockox and hung above the great fireplace
in his house – as a contemporary painting by Frans Francken
records. It is painted on a large oak panel prepared with a smooth
white chalk ground which gives an underlying luminosity to

73. Peter Paul Rubens, *Samson and Delilah*, about 1609–10 (detail).

74. Detail of fig. 73.

the colours on top. However, Rubens modified the brightness of the ground slightly by applying a thin streaky wash of grey-brown *imprimatura* before his colour layers. This was a technique that he also used in his small oil sketches both to soften the stark whiteness of the ground and to give a lively visual texture by virtue of the stripes showing through the thinner passages of paint. On *Samson and Delilah*, the striations of the *imprimatura* can clearly be seen between the folds of Delilah's white sleeve.

A useful documentary source for studying the techniques of Rubens and his contemporaries is a manuscript now in the British Museum, written by the Royal Physician Sir Theodore Turquet de Mayerne who met Rubens, Van Dyck and other painters at the English court and recorded technical observations in notebooks over a period of some twenty-five years (from about 1620–46). De Mayerne wrote that 'few colours are necessary for a painter in oil and mixtures of these few make and compass all the others' – and it is certainly true that, although the overall effect of *Samson and Delilah* is one of glowing colour, the range of pigments the painter has used is surprisingly limited. The brilliance and richness of the painting relies on the use of the red vermilion (for example, in the scarlet patterns of the carpet), the beautiful crimson-coloured lake pigment of Delilah's red dress [74] and lead-tin yellow in Delilah's gold-coloured cloak – along with lead white

and earth colours. There is almost no blue in the painting. The purple hanging drapery and the grey-blue coat of the man cutting Samson's hair, although distinctly bluish in tone, actually contain no blue pigment: they are made up of black, white and varying proportions of crimson-coloured lake. The same constituents were used for the bluish purple dress in the *Portrait of a Woman and Child* by Van Dyck, Rubens's famous pupil [50, 51].

Analysis has shown that the binder for *Samson and Delilah* is linseed oil. Rubens was known to be concerned that his oils were as clear and colourless as possible. In a letter of 1624 he gave instructions that if a painting left in a packing case had taken on a yellow tone from being kept in the dark (as often happened), then it should be exposed to the sun 'whose rays will dry out the surplus oil which caused the change'.

Velázquez and the Use of Coloured Grounds

The Immaculate Conception [75], an early work painted in Seville in around 1618, is a striking example both of Velázquez's brilliantly precise early style and of the economy of technique afforded by the use of a dark ground. Velázquez's later works, from the 1630s onwards, exhibit greater luminosity as a direct result of his use of light-coloured preparatory layers.

The ground on Velázquez's canvas is a dull brown colour and corresponds exactly to the Sevillian type used and described in *Arte de la Pintura (The Art of Painting,* 1647), the treatise written by his teacher and father-in-law, Francisco Pacheco: 'The best and smoothest priming is the clay used here in Seville, which is ground to a powder and tempered on a stone slab with linseed oil.' The advantage for painters of using a dark preparation is that its colour can stand unmodified for many parts of a composition. It can be used for shadows, or can be darkened further with a transparent glaze for deeper shadow. Lights and highlights are used to define forms rapidly and economically and, by painting the lights more thinly towards their edges, allowing the dark ground to show through, cool half-tones are automatically achieved.

The Immaculate Conception is a textbook demonstration of this technique. The mid-tones of the Virgin's hair and hands – and also the basic colour of the sky and landscape – are the dull brown of the ground itself [75]. The ground is undoubtedly more prominent than it would have been originally, since some of the paint layers on

75. Diego Velázquez,
The Immaculate Conception,
about 1618 (detail).

top have changed and become more transparent with time: this is especially noticeable in the sky where the blue pigment smalt has (as it often does) lost much of its colour and opacity.

Velázquez's palette for the painting is not extensive. Lead white and yellow earth were used for the lighter parts of the sky. The blue of the Virgin's mantle is azurite, laid over a monochromatic undermodelling which established lights and shadows. The deep plum colour of the dress is a red lake which has certainly faded to some extent. If we take pigment changes and increased transparency into account, we can imagine the original painting to have been considerably denser in colour and higher in tone.

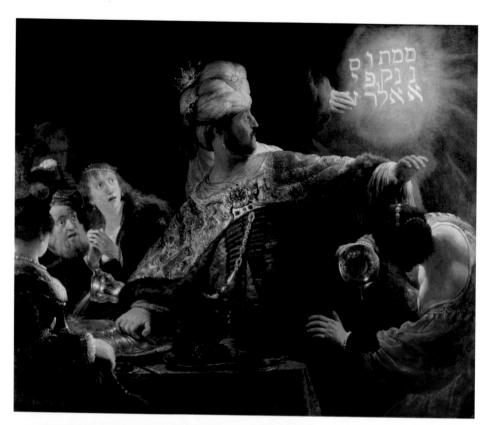

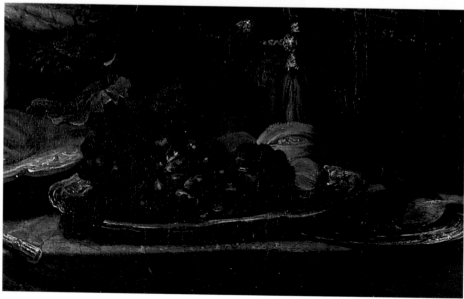

Rembrandt as Colourist

76. Rembrandt, *Belshazzar's Feast*, about 1636–8.

77. Detail of fig. 76, showing how Rembrandt uses a red lake layer to give subtle colour to the bunch of black grapes on the table.

Rembrandt's fame does not generally rest on his reputation as a colourist. Many of his pictures are sombre – even dark – and they are often dominated by warm reds, yellows and browns, as well as more profound darks. Even so, certain pictures repay a closer look at the way Rembrandt used colour, particularly in those from the earlier part of his career. The grand and striking composition of *Belshazzar's Feast* is remarkably rich in its colouring which is used to reinforce the dramatic tension of this night-time scene [76].

At the centre is Belshazzar's turbaned head and gold-encrusted, embroidered cape worked in very thickly applied oil paint, the various colours of which were blended while the paint was still wet. This is made up of an array of different earth pigments – yellow, brown and reddish-brown ochres, with the thickest, glistening highlights piled on top using lead-tin yellow and lead white. A little blue-green azurite appears here and there. These colours and impasto textures echo the paints used to depict the gold and silver plates and vessels on the table and the rim of the goblet being spilled at the right.

The woman spilling the goblet in startled surprise is dressed in rich red velvet. Rembrandt paints the fabric as deep shadows of red lake pigment and highlights made from vermilion and vermilion mixed with lead-tin yellow. The darkest shadows are lent a deep purple undertone by the use of a translucent red glaze over a layer of pure glossy black paint. The very dark purplish-black paint of the dress of the woman seated to the left of the composition involves a similar technique, although here the red lake layer is used very thinly to shift black paint just slightly in tone, in the same way as in the bunch of black grapes [77], while the purplish-red shadow cast by Belshazzar's cape across the right side of his body is intermediate in tone and also contains red lake. Painting treatises in the seventeenth-century practice recommended the use of an initial 'dead coloured' composition, in which the full design would be laid out in semi-monochrome, dull-coloured paints – dark greys, browns and blacks. Such a layer seems to have been unusual for Rembrandt, but appears to be present in *Belshazzar's Feast*. The sombre underpainting exerts a powerful influence on the colour and tone of the finished picture and imparts a light that is at the same time subdued and full of contrast. The conjunction of the simple, flat modelling of the flesh paints, the dark undercolours and their higher-key surface counterparts, produces a theatrical tableau of impressive power and intensity.

Eighteenth-century Brilliance

78. Giovanni Battista Tiepolo, *An Allegory with Venus and Time*, about 1754–8.

79. Canaletto, *Venice: Campo S. Vidal and Santa Maria della Carità* ('*The Stonemason's Yard*'), 1727–8.

Two Venetian painters, Tiepolo and Canaletto, particularly exemplify the breathtaking painterly skills coupled with brilliant high-key colour that reached a peak in the first half of the eighteenth century. Although each artist's subjects and artistic ambitions were very different and quite separate, there are striking parallels in the development and use of colour in their oil paintings. Both produced dark, dramatic compositions at the beginning of their careers quite unlike the bright, luminous work of their maturity. Tiepolo was influenced by the deep tones of earlier painters such as Giovanni Battista Piazzetta, while Canaletto's melodramatic early view paintings reflect his apprenticeship as a painter of theatrical scenery. Both progressed to a cool bright tonality in their paintings through the 1720s: Tiepolo as a result of his rapid mastery of the solid, pale colours of fresco, and Canaletto in response to the demands of patrons who, no doubt, wanted souvenirs of Venice in eternal springtime.

Both Tiepolo and Canaletto prepared their canvases with ochre-coloured grounds, ranging from reddish-orange to yellowish-brown. In their earlier paintings, the colour of these preparations was allowed to show through the paint and imparted a hot, dark tonality overall. Later, they painted much more opaquely: Canaletto, around 1730, began to use a dense grey or beige upper ground to give a cool, light tone to his paintings.

Both painters used the newly available Prussian blue, first synthesised around 1704-10. Tiepolo continued to use the traditional ultramarine blue as well – and the sky in the opaquely-painted *Allegory with Venus and Time* (about 1754–8) consists of exceptionally finely ground ultramarine with white, while Prussian blue is used for some of the draperies [78]. Canaletto embraced the new pigment more completely. Ultramarine is only found in his earliest work, of the early 1720s; thereafter he appears to have used Prussian blue exclusively. The blue of the sky in 'The Stonemason's Yard' (1727–8) is solely Prussian blue [79].

'The Stonemason's Yard' is transitional in Canaletto's stylistic development. The dark, stormy contrasts of his early work have disappeared, but he has not yet introduced the beige upper ground that imparted a blond brightness to his subsequent work [80].

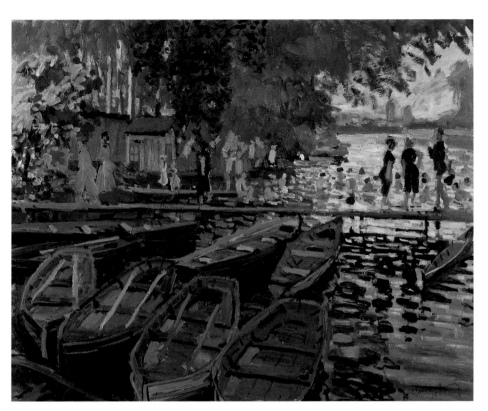

81. Claude-Oscar Monet, *Bathers at La Grenouillère*, 1869.

The Nineteenth Century – an Explosion of Colour

The rise of naturalism, and in particular, of naturalistic colour, as seen in the paintings of Turner and Constable, was to have a profound effect on nineteenth-century art, culminating in the experimental painting of the Impressionists. The idea of capturing momentary natural effects in paint was explored by Corot [3, 4] and Daubigny, but one of the first true paintings in what became the Impressionist style is Monet's *Bathers at La Grenouillère*, painted in the summer of 1869 [81]. Its subject is the well known bathing spot on the Seine at Bougival, just outside Paris. In a letter Monet described 'a few bad sketches' he had done for an intended Salon

picture – and this was one of them. Its technique is direct, impulsive and experimental, and anticipates the open, fragmented style that Monet was to develop in the 1870s. Painting with broad square-ended brushes and fluid opaque paint, Monet clearly worked at great speed to capture the rapidly changing effects of sunlight and movement. The flickering light effects were realised not only in patches of pure colour, but in the broken texture of the paint itself.

Monet's palette for the painting was large, reflecting the great increase in the availability of new synthetic pigments during the nineteenth century. At least 15 separate pigments have been identified, most of them inexpensive – reminding us of Monet's financial difficulties at this time. In general, the pigments are bright, high-key colours, which are used either as direct pure touches to create shimmering effects, or mixed in surprisingly elaborate combinations to produce drabber, darker tones. Throughout his career, Monet consistently used these two methods for constructing his colour effects. Pure strokes of pigment are applied over the whole surface of the picture – vermilion for the red flowers at the left, a streak of unmixed chrome yellow for a highlight on one of the boats and chrome green (a commercially prepared mixture of chrome yellow and Prussian blue) for the patches of yellow green foliage at the upper left [82]. Duller tones, such as the khakis and olives of the near boats, contain emerald green, viridian and cobalt blue – all individually strongly coloured pigments – while the greyer tones are similar, with black and white added. The deepest shadows consist of ivory black (which the Impressionists were later to eliminate from their palettes, declaring that 'there is no black in nature') together with cobalt blue and red ochre to impart nuances of colour, even in the darkest areas.

Later in his career Monet described his approach to painting a picture: 'When you go out to paint, try to forget what objects you have before you – a tree, a house, a field or whatever. Merely think here is a little square of blue, here an oblong of pink, here a streak of yellow, and paint it just as it looks to you, the exact colour and shape, until it gives your own naive impression of the scene before you.' By this time, Monet was busy constructing his own mythology of Impressionism as an art of spontaneity, responding in the simplest possible way to light and landscape. His own art was considerably more complex than that – as the unexpected colour mixtures in his paintings confirm – and his genius for capturing fleeting colour effects was based on an extraordinary synthesising vision.

Optical Contrasts and New Colour Theories

83. Georges Seurat, *Bathers at Asnières*, 1884.

Seurat is known to have had a particular interest in optics and the emerging theories of the science of colour in the nineteenth century. He was influenced particularly by the writing on colour of the chemist Chevreul, Director of Dyeing at the Gobelins tapestry works, by the theories of the aesthetician Blanc, and by the physicist Ogden Rood, as well as painters of an earlier generation such as Delacroix (see p. 64). In his own words, Seurat sought an 'optical formula' in his painting which would heighten the impact of his work by means of the juxtaposition of different colours. In the *Bathers at Asnières* Seurat exploits these ideas and discoveries in the most comprehensive way [83].

Bathers at Asnières, painted in 1884, is remarkably elaborate in its execution and Seurat's use of colour is fundamental to that complexity. The overall tonality of the painting is light, clear and bright, since many areas contain large amounts of lead white pigment, producing an almost fresco-like effect. But within this overall light-reflective quality, Seurat sets next to one another on the picture's surface, powerful hues of maximum colour contrast, as pairs of so-called complementary colours: orange against

84. Detail of fig. 83, showing
the hat on the grassy bank.

blue, yellow with violet and red against green. Chevreul had
discovered that when complementaries, which occupied opposite
positions on the colour circle he had devised, were seen next to
one another, then their colour effect was in each case intensified.
The use of complementary contrasts can be seen everywhere
in the picture, at the level of individual adjacent brushstrokes,
as well as between larger passages of colour. Each passage of a
dominant colour in the painting is made up of small brushstrokes
of complementary and contrasting colours interlaced with those

of the main colour. In the predominantly green foreground river bank, for example, there are strokes of the complementary hues of red and pink, and there are also individually placed brushstrokes of bright yellow and violet, and orange and blue woven into the pattern of colour. Elsewhere, passages of orange paint make complementary contrasts with areas of blue, as in the bather's trunks, hair and hat seen against the blue expanse of the river [85], while yellow-greens adjoin mauves and purples in the shadows cast on the grass and in the more distant trees. These optical contrasts cause the paint surface to shimmer with an intensity and brightness that flat areas of colour could never achieve.

Chevreul had also found that when a pale colour, formed by the addition of white, was seen next to its neighbouring hue on the colour wheel – for example, where pink, which is a tint of red, is adjacent to orange – then contrast between the two would be perceived by the eye as enhanced. *Bathers* shows the use of this optical effect as well, in the juxtaposition of pink-toned flesh against the orange bathing trunks and orange-red hat.

Seurat also used a marked contrast of tone, seen most strikingly in the light and dark haloes around the boys in the centre and at the right of the picture. Next to the lit sides of the boys' bodies, the water has been consciously darkened, and next to the shadowed sides it has been lightened. These variations are a painterly imitation of the reaction of the human eye, which perceives the same background tone as darker around a light object and lighter around a dark object.

As Seurat's art developed, he became more interested in breaking up the paint surface into smaller, more discrete dots of colour, and when he returned to work on the *Bathers* in 1886 or 1887 after a gap of over two years, he embarked on a last campaign on the painting, applying small spots of colour: yellow and green around the hat on the riverbank [84], blue and orange in the small of the back of the seated bather, and orange, yellow and blue on the hat of the boy in the water.

In looking at the pictures in this book, we have gone some way towards explaining what makes up colour in painting, its history, aesthetic and scientific theories about colour, and the optical processes involved in perception of colour. But we cannot entirely rationalise the painter's use of colour to create an illusion: there are too many variables, both in the painter's individual interpretation of the world, and in the viewer's response to it. Perhaps the sixteenth-century Venetian painter and writer Paolo Pino was very near the mark when he wrote that colour is 'the true alchemy of painting'.

FIND OUT MORE

The most comprehensive book on colour in art is: J. Gage, *Colour and Culture*, London 1993.

An indispensable work of brilliant, wide-ranging and impeccable scholarship. The same author's *Colour and Meaning*, London 1999, expands on many of the ideas in his earlier book.

Much useful information on colour in art will also be found in the following:
P. Ball, *Bright Earth: The Invention of Colour*, London 2008

D. Bomford, J. Dunkerton, D. Gordon and A. Roy, *Art in the Making: Italian Painting before 1400*, London 1989

D. Bomford, J. Kirby, J. Leighton, A. Roy, *Art in the Making: Impressionism*, New Haven and London 1990

D. Bomford, J. Kirby, A. Roy, A. Rüger and Raymond White, *Art in the Making: Rembrandt* (revised edition), London 2006.

J. Dunkerton, S. Foister, D. Gordon, N. Penny, *Giotto to Dürer: Early Renaissance Painting in the National Gallery*, New Haven and London 1991

J. Dunkerton, S. Foister, N. Penny, *Dürer to Veronese: Sixteenth-Century European Painting in the National Gallery*, New Haven and London 1999

M. Hall, *Colour and Meaning: Practice and Theory in Renaissance Painting*, Cambridge 1992

M. Kemp, *Science and Art*, New Haven 1990

T. Lamb and J. Bourriau (ed.), *Colour: Art and Science (The Darwin College Lectures)*, Cambridge 1995

H. Rossotti, *Colour*, Harmondsworth 1983

The National Gallery Technical Bulletin, published annually since 1977, is a record of research carried out at the National Gallery, London, and contains many articles related to colour in painting. Technical Bulletin articles are also available online, see **www.nationalgallery.co.uk/technicalbulletin**.

All photography © The National Gallery, London except:
London: fig. 23 © The Natural History Museum, London;
fig. 57 © akg-images
Private collection: fig. 10 © The Bridgeman Art Library

FSC
Mixed Sources
Product group from well-managed forests and other controlled sources
Cert no. SGS-COC-002987
www.fsc.org
© 1996 Forest Stewardship Council